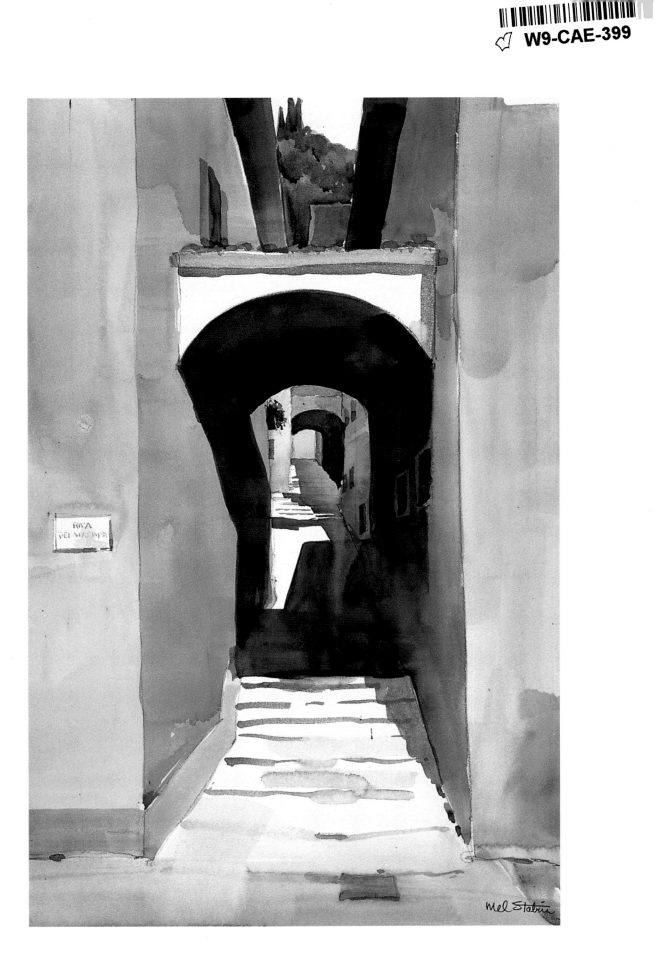

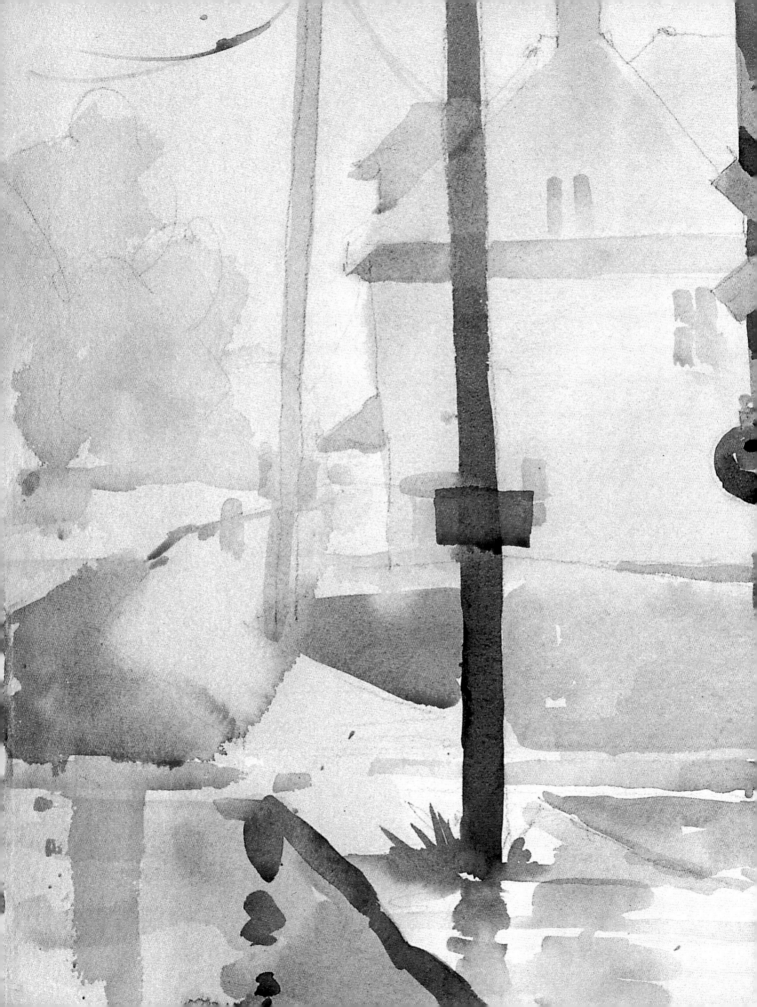

WATERCOLOR

simple, Fast, and Focused

Essential Concepts for Mastering the Medium

MEL STABIN

Watson-Guptill Publications

Mel Stabin

To Aileen and our children Kevin, Dana, Thea, and Nesa.
And to my students, for whom my affection is unbounded.

FRONTISPIECE:
A Street in Varenna, 22 x 15″ (56 x 38 cm)

TITLE PAGE:
Morning Fog, 15 x 22″ (38 x 56 cm)

SENIOR EDITOR: Candace Raney
EDITOR: Victoria Craven
DESIGNER: Patricia Fabricant
PRODUCTION MANAGER: Ellen Greene

Copyright © 1999 Mel Stabin

First published in 1999 in the United States by
Watson-Guptill Publications
a division of BPI Communications, Inc.
1515 Broadway, New York, New York 10036.

Library of Congress Catalog Card Number:
99-62970

ISBN: 0-8230-5706-2

Printed in Malaysia

First printing, 1999

1 2 3 4 5 6 7 8 9 / 07 06 05 04 03 02 01 00 99

If you try, almost anything is possible.

ABOUT THE ARTIST
Mel Stabin has maintained dual careers for over
thirty years as an award-winning art director/creative
director for major advertising agencies in New York
and as a watercolor painter-teacher.

Mel is a popular watercolor instructor and has
conducted workshops throughout the country and
abroad for over fifteen years. His paintings have
been honored with many national awards and are in
many private and corporate collections.

Mel and his wife, Aileen, reside in Bearsville,
New York.

Acknowledgments

One of the greatest influences on and source of inspiration in my life was Ed Whitney. He was my mentor and my friend.

My thanks also go to Candace Raney, senior acquisitions editor at Watson-Guptill Publications, who recognized the potential for this book when it was still just an idea, and guided it through completion. Victoria Craven, my editor, also deserves my thanks for all her hard work.

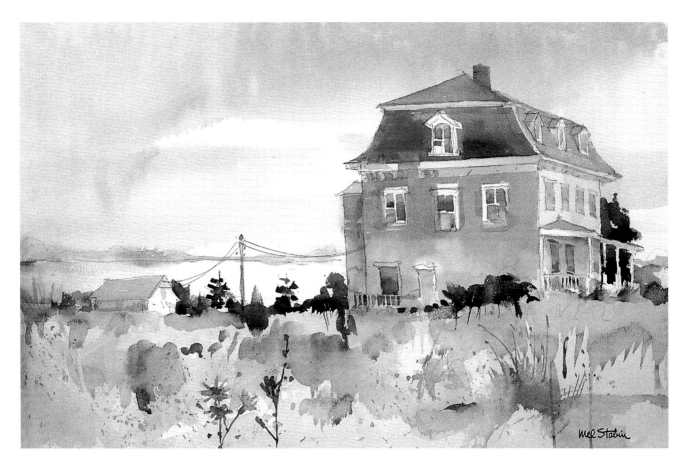

Captain's Mansion, Block Island
15 x 22″ (38 x 56 cm)

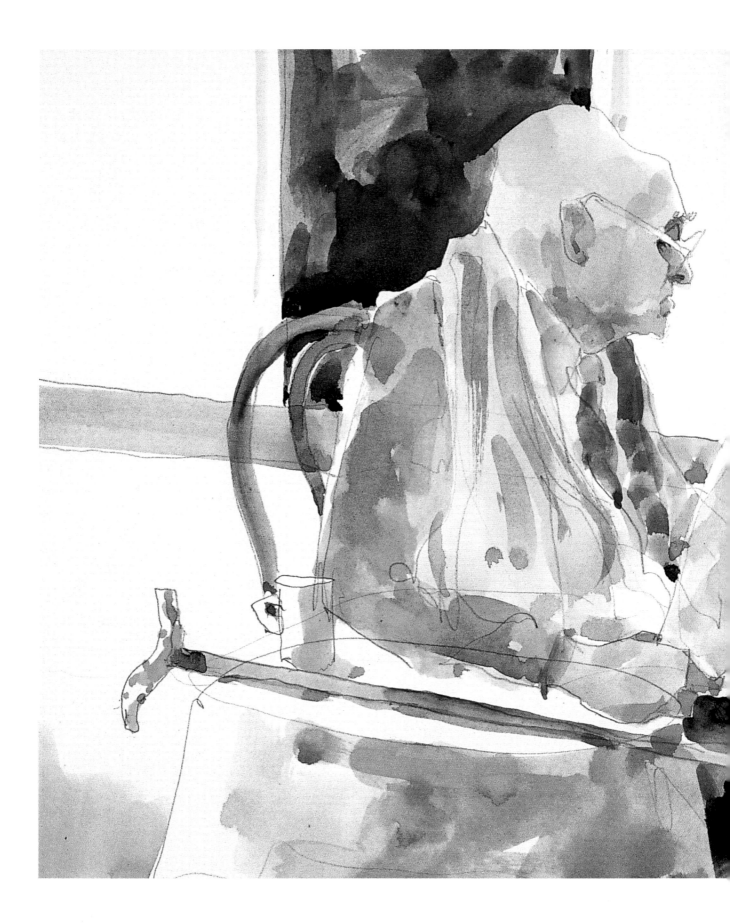

Contents

Gentleman of Assisi, 9 x 12" (23 x 30 cm)

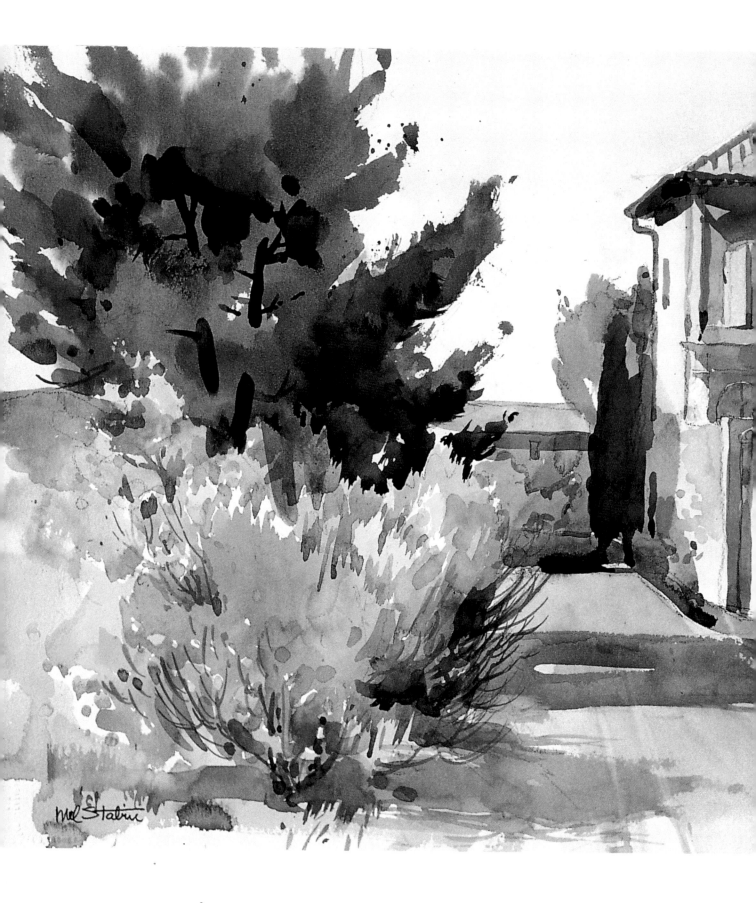

Preface

Any number of instructional books on watercolor techniques are available for beginners and advanced painters. Though this book thoroughly covers the "how to" of watercolor painting, its objective is not to emphasize technique. Technique will emerge as a result of production, but does not make a painting.

Of course, knowing the rudiments of painting is essential in order to paint with authority. However, when you become proficient in the application of technique, don't feel that you have "arrived." Unfortunately, many artists do. Technical proficiency is just the beginning.

Watercolor likes to misbehave. It is at its best when it is set free and does what it wants. It can exasperate and exhilarate. That is why I have had a love affair with watercolor for over three decades.

It is my hope that by sharing with you my painting experiences, thoughts, and the knowledge acquired through more than thirty years of painting and conducting workshops, you will learn from my experiences, go beyond technique, increase your stature as an artist, and produce creditable paintings.

L'Hôpital de Van Gogh
15 x 22" (38 x 56 cm)

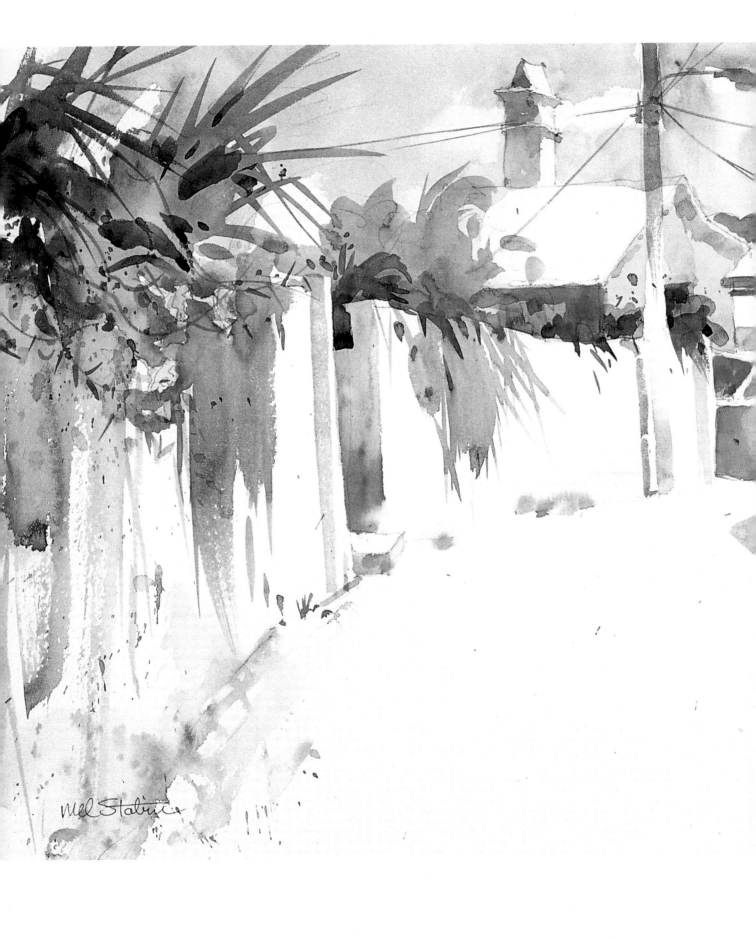

Introduction
"The Big Three"

Your painting will reflect your state of being.

To create a painting of substance, there are three essential activities done as part of the painting process that are worthy of serious consideration—I call them "The Big Three."

1 *Simplify.*
2 *Think and paint quickly.*
3 *Focus.*

A simple explanation of "The Big Three" includes all the essential concepts for mastering the watercolor medium. It is important that you understand and then perfect the use of these elements in your work. Instruction on how to do this is interwoven throughout this book. The chapters that follow present specific information on equipment, design, value pattern, color, painting the figure and portrait, and painting outdoors. Always keep in mind the goal of working simply, quickly, and with focus.

Beautiful Bermuda Day
15 x 22″ (38 x 56 cm)

Simplify

It is with good reason that we find joy in children's drawings and paintings. They are colorful, naïve, direct, big, but most of all simple. Because their minds are uncluttered, so is their art.

Consider the economy and sureness of brush strokes seen in the paintings of Sargent, Whistler, Henri, and other masters. Their work appears effortless and simple.

Simplicity is a powerful force.

Simplifying your approach to subject matter requires *thinking simply*. Every brush stroke you make reflects exactly the way you think and feel at that moment. If you are distracted or focused, happy or unhappy, confident or hesitant . . . it will show. Remember, also, that painting is a process of subtraction, not addition. Resist the urge to include everything you see in your painting. Include only those elements that are *expressive* of your subject and ruthlessly eliminate those that are not. Consider what to *omit* from your painting as well as what to *admit*. Simplify. Simplicity is the solution to both the problems of complexity and chaos.

When you decide on the subject you want to paint, your first question should be "What is the simplest, most direct way to translate my feelings on to the paper?" To answer, first break down the elements of your subject into their simplest shapes. Deciding what the shapes of your subject are, how they relate to one another, and where they reside on the paper is the beginning of composition.

When you are satisfied that you can clearly "see" the idea of your painting in your mind, you are ready to begin.

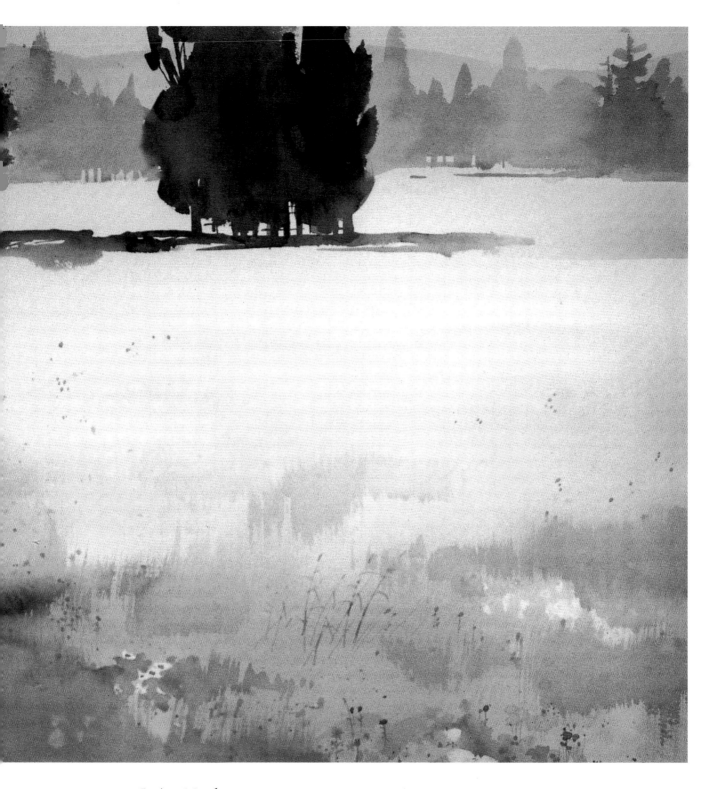

Spring Meadow, 22 x 30" (56 x 76 cm)
The many individual trees that I actually saw were condensed to three simple shapes. The three acres of meadow were described as a gradation of pale washes, warmer at the top, with darker rhythms of color coming down into the foreground. The suggestion of wildflowers was enough to describe the entire meadow.

Think and Paint Quickly

Don't fiddle around. If you believe that watercolor is the *fastest* medium and that partial statement of details is desirable, then you will find that thinking and painting quickly is a valid approach. You will be amazed at the amount of thought that can go into a quick decision *if you are focused*.

Painting quickly in watercolor gets you to the heart of the matter without delay or the distraction of unnecessary detail. Keep your thoughts at an energized level so that when they are translated to paper they maintain their vitality. It is also valid to contemplate and distill painting ideas in your mind for long periods of time . . . weeks, months, years— but that occurs *before* the painting process. Painting quickly helps to keep you "seeing" the big, simple picture—the essence of your subject.

The worth of your painting does not depend on how long it took to paint it.

It is far better to create many paintings—being focused and working quickly and simply—than to try to paint a masterpiece. Production is important. Some of your paintings will fail. Some will succeed. We learn from our failures. Look forward to them. They are part of the process. If my watercolors are more successful than yours it is because I have failed more often than you have. Among those who only paint every now and then, there's a tendency to want to do "major paintings." These painters often get very uptight results. Remember, it is "the process" that is important. A painting is a by-product of "the process." The joy and excitement is in the act of painting itself. A greater sense of freedom and ease will be evident if you paint and think quickly. There is no virtue in delaying. Set yourself free. Put some guts into your work. Walk on the edge. Andrew Wyeth did some of his best watercolors in twenty minutes. If you don't "fiddle around," hoping that more and more detail is going to "save" your painting, you will find that being alert, energetic, and quick will be a rewarding experience.

Spanish Guitar Lady
15 x 22" (38 x 56 cm), (Collection of Karl Williams)

Painting quickly helped discipline me to see only the large masses of shapes, colors, and values. I wanted a spontaneous impression of the figure, so I laid down the washes once—going for the correct color and value—and never went back. If the big shapes are resolved, you don't need much detail. This painting was completed in forty-five minutes.

Boat Slip at Dillman's
15 x 22" (38 x 56 cm), (Private collection)

The life vests hanging from the rafters of this boat slip caught my eye and became the idea for this painting. The colors of the vests were not actually this vivid. As a foil for the vests, I kept the rest of the painting neutral and quiet.

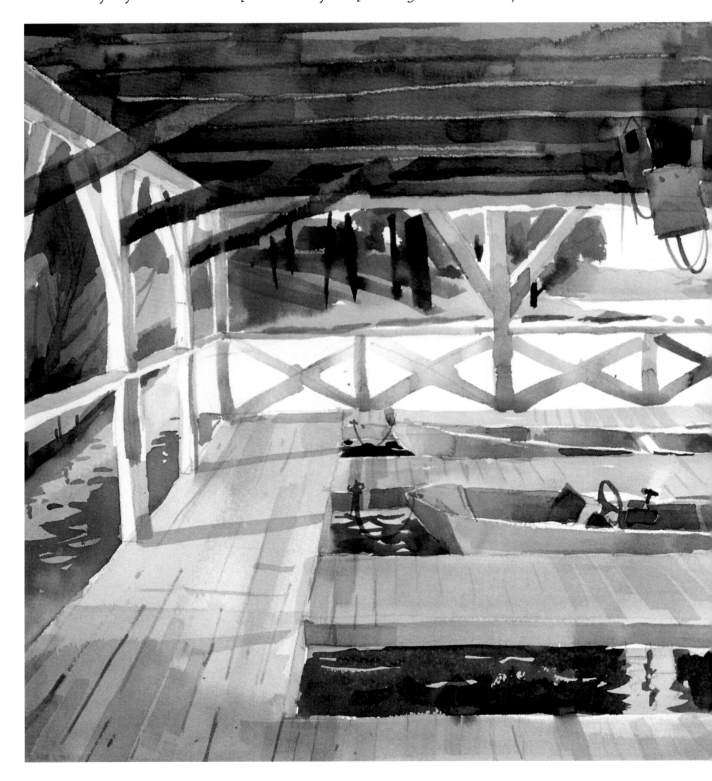

Focus

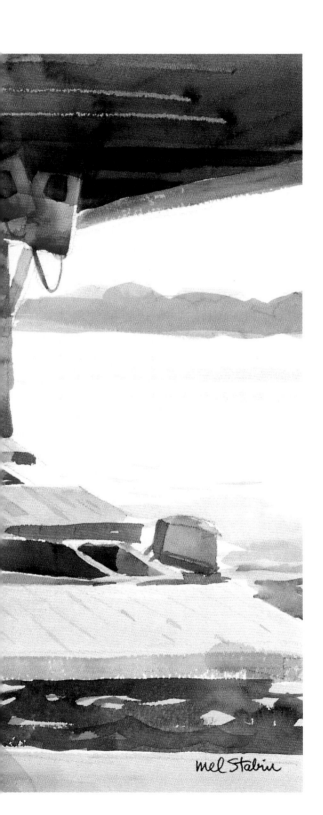

What is the one idea that you want to express, that really moves you? You are allowed only one. Is it the reality of the meadow seen against the receding mountains or is it the sense of morning light affecting the landscape? Is *that* the essence of your subject? What is the attraction of the model? Is it the gesture of the body? The head? The attitude? The light? Take a moment to really understand your feelings and to have convictions about them.

Clarity of thought and emotion are essential in art.

Walk around your subject. Smell the air. Listen. Touch. Think. Concentrate. Be aware. Attitude, point of view, your vision of the painting that is yet to come must dictate everything . . . composition, color, value, rhythms, and so on. Technique does not. That comes later. Learning to focus is a form of meditation, of being as one with your subject. If you are truly focused your painting will develop quickly and effortlessly and, in a way, paint itself. Every brush stroke will count, color will be significant, and shapes will be dynamic. Observe the art of a zen master artist. The brush strokes are at once confident, sensitive, accurate, direct, gestural, expressive, and simple. One stroke of the master's brush speaks volumes. A flick of the wrist and a sparrow appears. Need more be done to "express" the gesture of the bird? No. It is perfect in the state that it was done because the state of mind was perfectly focused. Empathize. Know what it feels like to be your subject. The trick is to stay focused on the painting idea from beginning to end. Do not allow unnecessary detail or a glib moment to blur your focus.

Beware and be aware of reality for its own sake. Hold on to *your* vision.

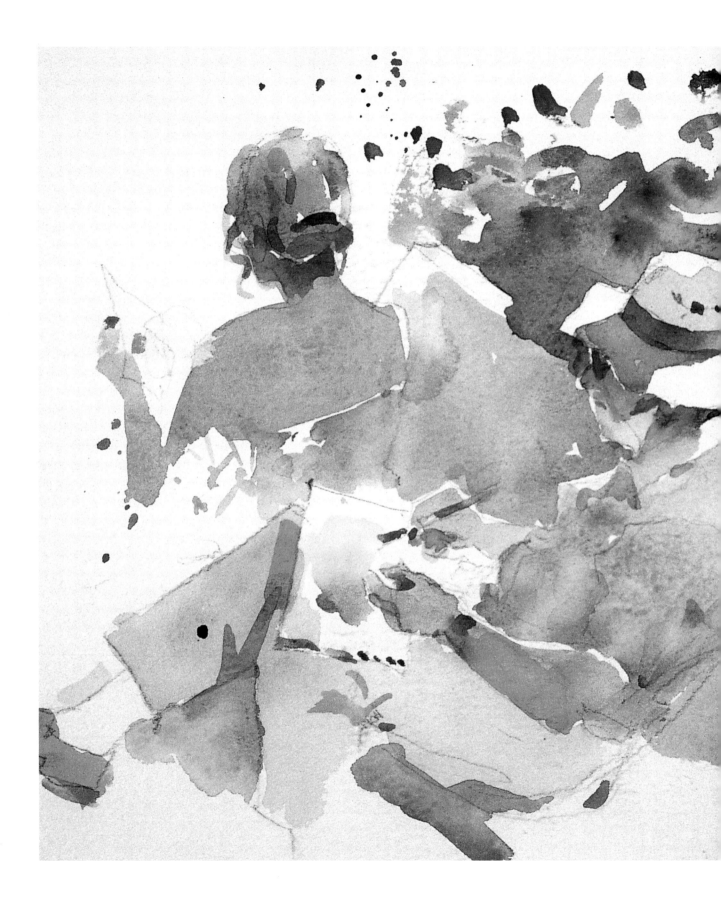

Equipment

The Right Tools for the Job

*An artist is a crafts-
man in love with
his or her tools.*

The following painting materials recommendations are not earth shaking. They are basic and can be added to as the need arises. A watercolorist is a gadgeteer or will become one as soon as "gimmicks" are discovered. I guess that I've experienced most of them during my painting life and have made a point to simplify things. I don't use kosher salt, for example. I don't use maskoid or frisket. I don't spray paint for an "effect." I don't like gimmicks. There is a definite line between a painterly painting and a painting that looks crafty.

Discover and experience different tools and materials. It is part of your education, but be selective and resist any tool or technique that will overpower the idea of the painting. If you are fairly new to watercolor painting, the information about equipment will be very helpful. If you are an experienced watercolorist, most of the information in this chapter will be very familiar to you, but it never hurts to review.

Annabel & Brian Brough
(from London) sketching
at Lake Como. 7/12/98

Annabel and Brian
7 x 10" (18 x 25 cm)

Palette and Other Essentials

For both studio and location work I use the **John Pike palette.** It contains twenty good-size wells and a large mixing area. It measures 10 1/2 x 15". The palette itself is made of heavy-duty injected plastic. The colors are arranged in a simple manner, light to dark and cool to warm within color families. (See pages 22-23.)

As a **sketching tool,** use a 2B or 4B graphite pencil—it's dark enough to register a strong line but is not too hard. Don't use a hard pencil (H). It's like a nail and tends to dig into the paper. Other instruments you may like to work with are charcoal pencils, pens, quills, reeds, sticks . . . whatever. If you want to erase, use a **kneaded eraser** only. It is soft, lasts a long time, and won't mar your paper.

Also with your palette, you should have a **small pocketknife** for "flicking" out a highlight, "lifting" out tree branches and pilings from backgrounds, and for sharpening pencils.

Another tool that should be part of your basic set-up is a soft rubber mixing **spatula.** This is useful for squeegeeing out light areas in darks, as in rocks, windows, and so on. I break off the handle of the spatula and just use the spatula itself.

As **water container,** I prefer a plastic or aluminum 8-inch baking pan with 2-inch side walls for indoor work. You don't have to dip your brush into 6 inches of water to get to the bottom. You can tamp out color from the brush in 1 1/2 inches of water in the pan, without going beyond the ferrule. For painting outdoors, I use two 5-inch Tupperware plastic jars that fit onto the tray that attaches to my easel. Any screwtop plastic container, canteen, or waterproof "duck" canvas bag, which I use, is fine for carrying water.

Use a natural animal **sponge** for wetting your paper. Use a rectangular cellulose sponge for checking excess water on your brush and for keeping your paints moist when the palette lid is closed. I keep three of them in my palette.

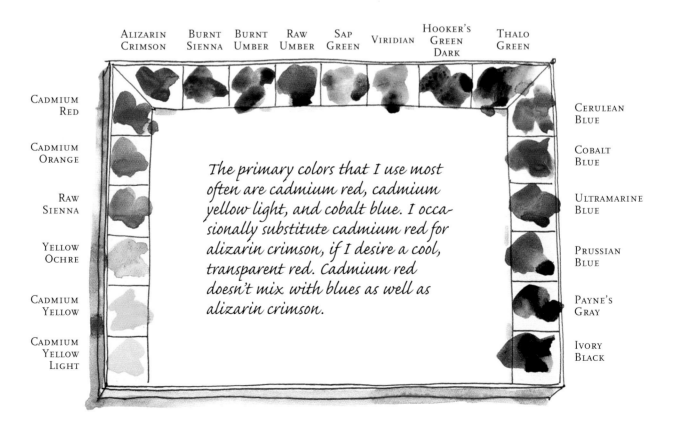

The primary colors that I use most often are cadmium red, cadmium yellow light, and cobalt blue. I occasionally substitute cadmium red for alizarin crimson, if I desire a cool, transparent red. Cadmium red doesn't mix with blues as well as alizarin crimson.

Paint

Use tube paints only. It is important that you have moist color available every time you dip your brush into paint. Avoid using dry pan paints. They never give you the "juicy" fidelity of color needed for watercolor. Dry pan paints are okay for quick small sketches, but even for these my preference is tube color.

Buy artist- or professional-grade tubes, not student grade. Quality of color and costs will vary with different manufacturers. The label on the tube of paint will usually code the degree of lightfastness and permanency—some colors are fugitive. The manufacturers make color charts available that explain the properties of their colors. I use both transparent and opaque colors. Opaque colors are valuable in that they have body and lighter colors can be placed on darker when needed.

Winsor & Newton, Da Vinci, and Holbein manufacture colors that maintain high quality standards and there is an enormous variety to choose from. Prices and tube sizes vary so it pays to shop around.

Friends, 22 x 15" (56 x 38 cm)

Paper

There are many papers on the market to choose from. I mostly use Lanaguarelle and Arches 140-lb. cold-press: Lana for its whiteness and Arches for its toughness. It is easier to manipulate the paint (OK?) on Arches because the paint isn't absorbed into the paper as readily as it is on the softer texture of Lana. I also enjoy working on hot-pressed paper, especially on small blocks or pads. The paint reacts differently on hot-press. Because of its smoothness, the paint glides on the surface and interesting areas of color can occur because of capillary action. Other papers that I like are Fabriano, Winsor & Newton, and Strathmore Bristol. Again, I don't find it necessary to go beyond 140-lb. weight. Handmade papers of 100 percent cotton fiber are preferable. There are some synthetic papers that work nicely as well. Strathmore Aquarious is one that I've used with some success. Washes appear very transparent on this surface and the paper will not buckle. Paper selection is personal so you should experiment.

Easel

Most of my landscape painting is done on location and, after some trial and error, I have discovered a system that is well designed and perfect for all of my traveling needs.

My tripod easel has retractable legs that can open to three heights. It is well engineered of lightweight aluminum alloys. It holds a strong plastic tray that attaches to the legs. The tray holds my Pike palette and two 5-inch Tupperware plastic jars for water. The easel has a small chain that drops down from the middle of it to hold a 3-lb. weight that helps stabilize the easel in windy conditions. A composite lightweight board attaches to the head of the tripod and can be tilted in any direction or swiveled 360 degrees. My board is the size of a half sheet of paper. The tripod easel collapses to a size that fits into a sleeve of a nylon carrying bag designed to carry it, the board, the tray, my palette, and all of my materials. Make sure your carrying bag (made of either a good nylon or heavy-gauge canvas) has big pockets and a zipper that works well. The bag should measure a couple of inches larger, all around, than your half-sheet size. It should be thick enough to accommodate all of your material.

If you paint in plein air, an aluminum and canvas folding stool is another must-have item. These stools can be found in art supply stores or camping outfitters. Some have shoulder straps, backs, and pockets for storing art supplies. Get a well-made one. I used a stool for many years, but now prefer standing at the easel. When my bones begin to feel a little stiff from standing in one spot too long, I just move around a bit to work out the kinks. My daughter Thea, a terrific chiropractor, insists that I do this.

Whenever I paint indoors, I use an adjustable table easel.

Materials Checklist for On-Location Painting

- EASEL
- PALETTE
- TRAY
- WATER CONTAINERS
- TUBE PAINT CONTAINER
- FOLDING STOOL
- RUBBER SPATULA
- SPONGES
- RAG
- SKETCH BOOK
- 15 HALF-SHEETS OF PAPER
- BRUSHES
- PENCILS, ERASER, KNIFE
- NYLON CARRYING BAG

Easel
One of the benefits of this easel is that the entire set-up can be moved with one hand if it begins to rain.

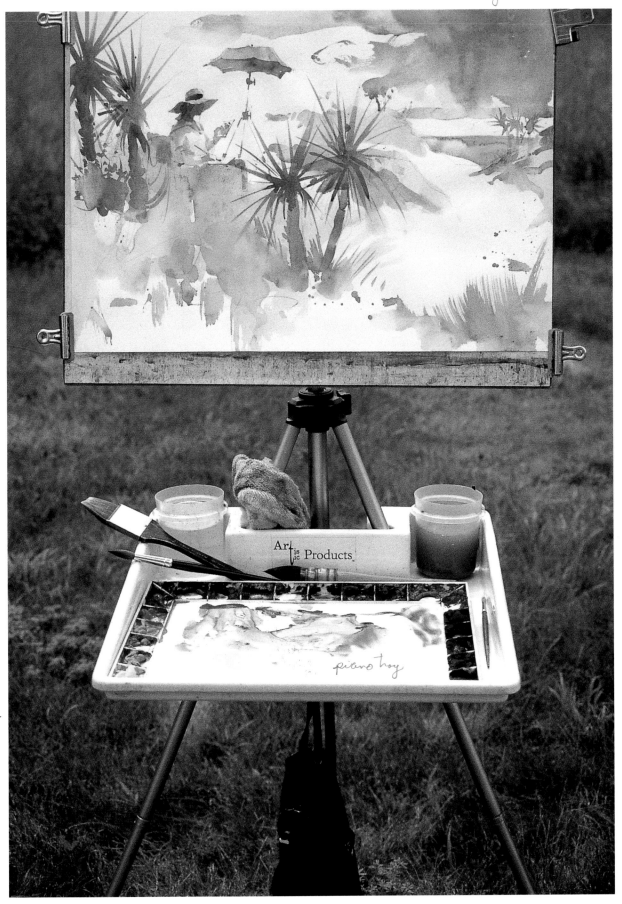

piano tray

Brushes

There are many shapes and qualities of brushes to choose from. I suggest a couple of flats and a few rounds to start with—a 2-inch and a 1-inch flat sable. These brushes are valuable for covering large areas quickly. The marks they make have a square, sharp-edged character. Round sable brushes nos. 14, 10, and 6 or 8 make a different mark. A no. 4 rigger is also a handy brush to have for "snappy" calligraphic marks.

I use a couple of expensive pure Kolinsky round brushes (especially for figure work) and some relatively inexpensive brushes made of a combination of natural and synthetic hairs.

Brush Handling

The best tool ever made for painting is still the brush. Every brush makes a distinct, unique mark. Different brushes are employed for different functions. Flat, square brushes are useful for covering large areas and they make a sharp-edged mark. The end of a flat brush can deposit a razor-thin mark if held perpendicular to the paper.

Unlike the flat brush, the round brush makes a cylindrical mark that can change in thickness depending on how it is manipulated. There are also oval brushes, angled brushes, long-haired "riggers," brushes made of Styrofoam and from the hairs of sables, fox, ox, pony, squirrel, camel, and other assorted animals, as well as nylon.

HAKE (PRONOUNCED HOK-EE)
One flip of this brush against the paper can indicate a hundred blades of grass.

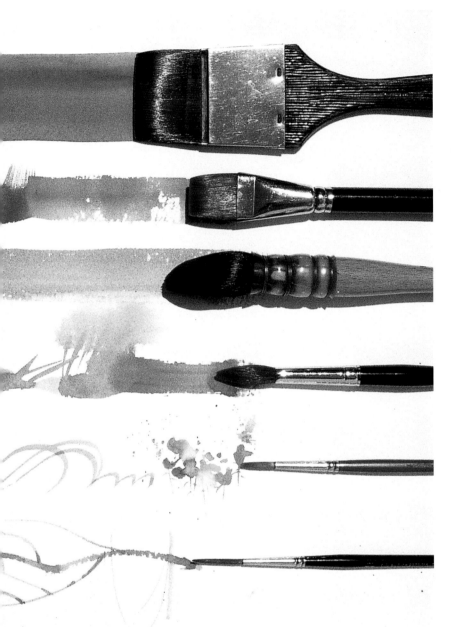

top to bottom:

FLAT, SYNTHETIC, OR NATURAL HAIR BRUSH (2-INCH)
Covers large areas with a single wash. Held perpendicular to the paper, the brush deposits calligraphic marks.

FLAT SYNTHETIC BRUSH (ONE-INCH)
Functions like the 2-inch flat in the marks that it makes. The square edge is useful for describing square shapes—windows, doors, rocks, boxes, and so on.

ROUND MOP BRUSH (NO. 10)
Holds a tremendous amount of water and pigment and will cover large areas quickly. The sharp point is valuable to suggest detail.

ROUND KOLINSKY SABLE BRUSH (NO. 12)
This excellent (and expensive) brush holds its shape and is the best average size for detail and broad washes, especially for figure work.

SCRIPT LINER RED SABLE BRUSH
The small chisel edge is very valuable for indicating thick and thin lines and is perfect for suggesting signage.

RIGGER BRUSH (NO. 4)
The long hairs provide flexible, fluid, thin marks. Held at the tip of the handle and swung from the elbow, the suggestion of clotheslines, telephone lines, a ship's rigging, twigs, and so on can be made with authority.

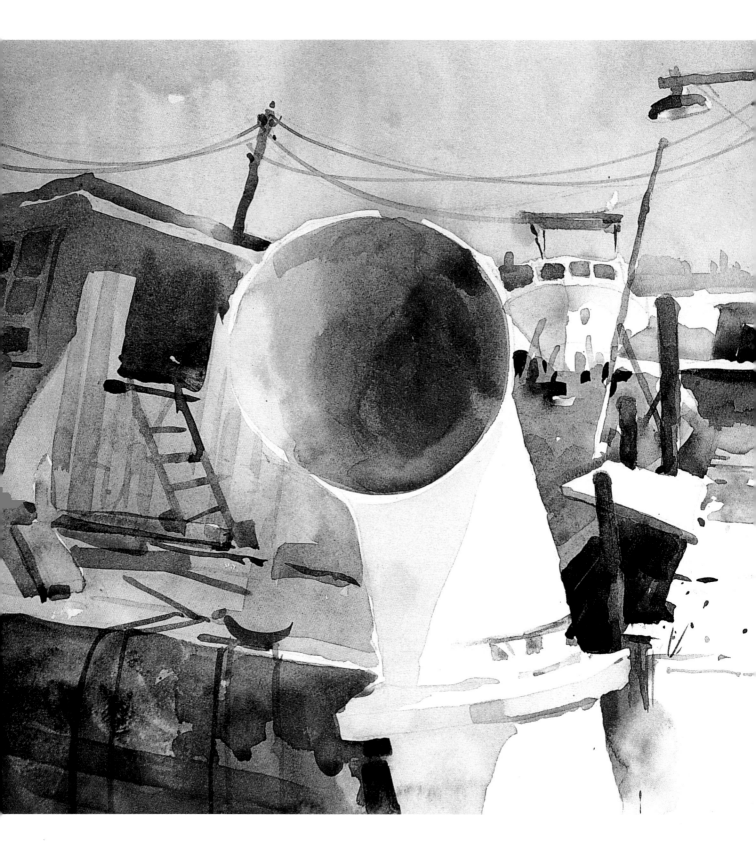

Designing Your Painting

Universal Principles of Design Explained

Designing your painting is the opposite of waiting for a miracle to happen.

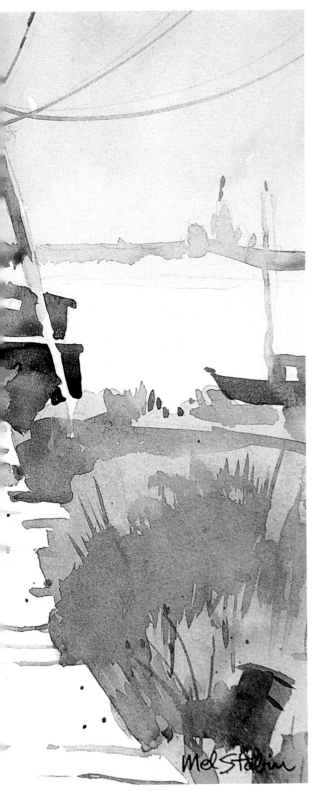

Edgewater
15 x 22" (38 x 56 cm)

Eight universal principles have guided artists throughout the centuries: unity, conflict, repetition, alternation, dominance, balance, gradation, and harmony. Before you become concerned with developing a "technique" or a "style," you must learn and practice these design principles. If your desire is to create creditable paintings, think of design principles instead of "how do I get that wood texture on that barn?"

The elements or "tools" of design that artists have to work with are line, color, value, texture, size, shape, and rhythm (or direction). Any or all of these elements can be employed by any design principle to arrive at a desired effect or fulfill an idea. Some artists are colorists. Some regard shape or value as the most important element in a painting. We all have different desires and objectives as artists. Whatever your vision, though, you need to respect the importance of design in your art, become very familiar with it, and then challenge it. Push the envelope. Grow.

Unity

Unity in your painting gives it a sense of wholeness, a unification of all the painting's elements. The whole is more than equal to the sum of its parts and far more important than any one of them. Unity is the primary aesthetic consideration in art. Every element of the painting must connect to the whole. (See *Lobster House, Maine,* below.)

Conflict

Interest in a painting is established when conflict is created. A hot color next to a cool color, dark values next to light values, fluid washes next to rough brush marks, calligraphic marks near quiet passages, high-intensity color in contrast to neutral colors, and so on. Conflict creates excitement, which, if not controlled, can result in an unstable or chaotic painting.

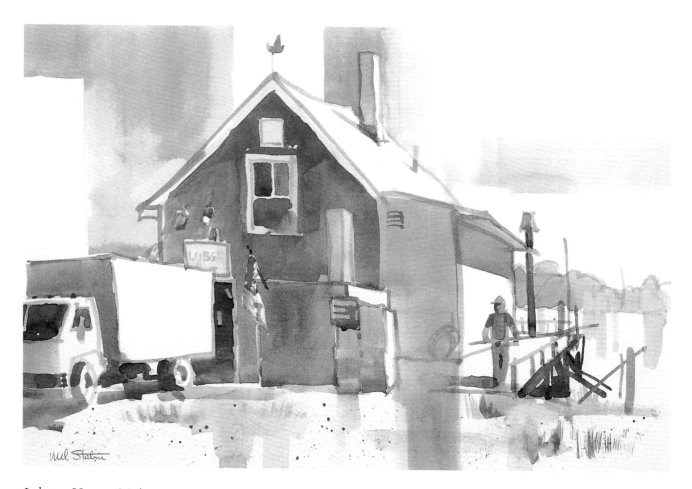

Lobster House, Maine, 15 x 22" (38 x 56 cm)

This painting has a modernist approach in that my concern was for creating strong spatial relationships, and communicating an awareness of the flat two-dimensional surface of the paper. I drew with a brush. The calligraphic marks contrasted with the large flat washes created an exciting tension. The rectangular theme imposed in the sky created unity throughout. Nature took a backseat in this painting. It is very healthy to experience other ways of painting, other ways of thinking.

Repetition

A clone of a single element or the echo or similar repetitive statement of a thing, really any thing. Vertical telephone poles, trees, dune fence slats, waves, clouds, chair legs, soldiers, and so on. The repetition of these shapes creates a recurring theme that helps to add unity, as well as interest, to your painting.

Alternation

Alternation is repetition with variety. Uneven pilings of a wharf, trees in a forest with trunks of varying girth and height, stones in a wall, and so on. Alternation creates excitement in repetitive forms. In *Turbotts Creek, Maine,* (below) the cadence of the pilings became the idea for this painting. This hand-hewn structure is typical on the Maine coast.

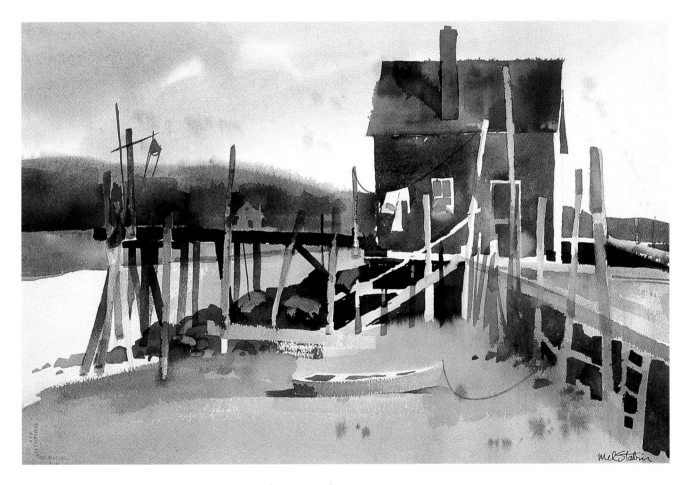

Turbotts Creek, Maine, 15 x 22" (38 x 56 cm)

The dynamics of this painting come from the alternating rhythm of the dock pilings. The area of greatest contrast occurs where the white pilings, clothes, and loading dock meet at the house. The diagonals of the creek, beach, and wharf direct the eye to the area of interest. The pilings are varied in height, value, and color.

Dominance

To eliminate chaos and to reassure unity in a painting, dominance is used to create a focus, or primary interest, usually described as the "center of interest" or "the idea." Dominance can occur in color, value, shape, size, or any element that the artist works with. If dominance is not present, by design, all the parts of the painting end up competing for attention and the result is surface decoration not art.

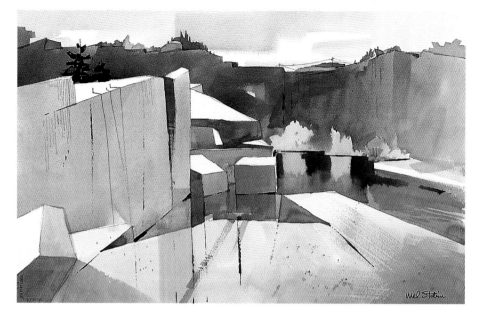

Granite Quarry, 22 x 30" (56 x 76 cm), (Collection of Caryl Aibel)

The use of dominant straight edges was designed into this painting to emphasize the "hardness" of the granite quarry. It is apparent in the clouds as well. The foreground ledge thrusts the viewer into the painting. When you impose an idea, be generous with it.

Balance

We usually think of balance as the even distribution of elements. In art we also have the opportunity to visually balance elements in an asymmetrical fashion. A large square shape balanced by three smaller squares (or circles). A long horizontal thrust balanced by several small verticals, a large mid-tone area balanced by a couple of small darks.

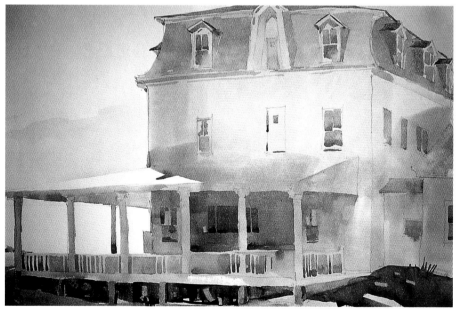

Narragansett Inn, 15 x 22" (38 x 56 cm)

The building and the blue-purple color dominate here. The feeling of early morning light is enhanced by the contrast of the cast shadow of the house against the white sun-lit porch roof, and the reflected light flooding into the side of the structure and under the porch roof.

Gradation

Gradation is gradual changing in successive stages. Sameness is the antithesis of change and can be very boring. Change in nature is the only absolute—nature is constantly changing. Gradation occurs in skies that are usually deeper and bluer at their zenith and lighter and warmer at the horizon. Gradation is seen in the reflection of the sky in still water. In buildings, shapes recede in perspective, and cast shadows, light on the figure as it spills softly into shadow. Any gradation (change) in color, value, texture, size, shape, line, or rhythm creates interest.

Harmony

Webster's dictionary describes harmony as "a pleasing, agreeable, congruent arrangement of parts." Tranquility of elements could be another description of harmony. In color, harmony can be created by the use of an analogous color scheme, or family of colors—yellows and oranges, purples and blues, greens and yellows. Using an overall color as the foundation for a painting can create harmony. Harmonious values would be close in a range of values—grays as opposed to black and white.

The Mad River, Vermont, 15 x 22" (38 x 56 cm), (Collection of Betsy and George Wick)

The horizontal rhythms of sky, mountains, and foreground are interrupted by the diagonal of the river. The clouds link the tree on the right to the smaller tree on the left. The gradation of value in the river welcomes the viewer into the painting.

St. George's, Bermuda, 15 x 22" (38 x 56 cm)

The pastel colors on a sunny day served as the idea for this painting. I executed it with flat washes and hard edges. My primary concern was with shape. Note the "dance" of the white and dark shapes. The value pattern is a large light and small darks against mid-tones.

Composition

Composition can be described as an arrangement, organization, or gathering of diverse elements into a unified whole. Colors can be aggressive, recessive, or neutral. Values are light or dark or anything in between. A shape can be abstract, large or small. Textures are obvious or implied. Rhythms can either soar or be gentle. Being aware of the relationships of the immeasurable variations of these elements and composing them on a two-dimensional sheet of paper is the job we have to do.

Before you touch pencil to paper you should try to visualize an approximate composition for your subject. I usually form a rectangle with my hands, scanning the scene before me, and then in the roughest, simplest manner, I indicate the big shapes on the paper. My focus at this stage is to divide the paper into dynamic areas and to determine where the elements will reside in the composition. It is somewhat of a Mondrian approach. I select an area of the paper for my major interest very carefully. The "center of interest" demands the most attention if it is placed in an area that is a different dimension from the four edges of the paper. This is an optical

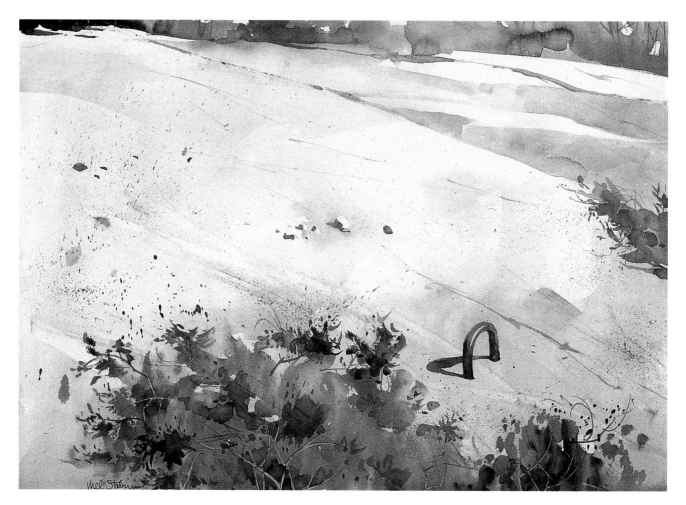

Granite Quarry Ledge, 26 x 30" (66 x 76 cm)

The thick metal loop imbedded in the rock was used to hoist huge blocks of granite out of the quarry. Note the placement of the loop in the composition. The greatest value contrast, color, and texture were devoted to the loop and scrub plant (area of interest) while the rest of the painting was indicated with simple broad washes.

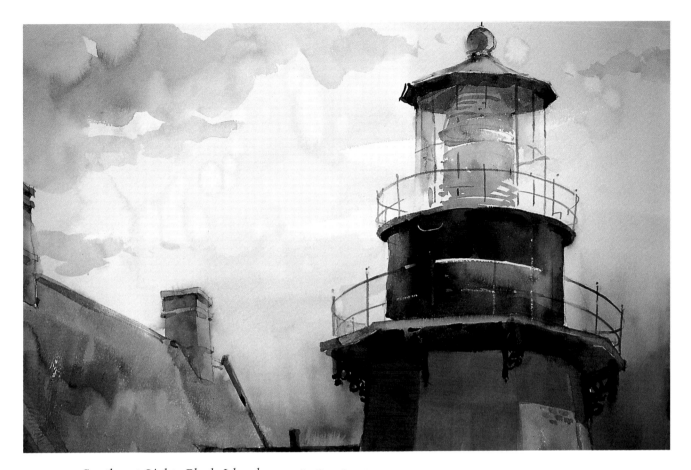

Southeast Light, Block Island, 15 x 22″ (38 x 56 cm)

Cropping in to a close-up of a subject often creates a dynamic composition. The huge light of the lighthouse was placed in an interesting area of the rectangle—a different dimension from the four edges of the paper. The interlocking positive shape of the lighthouse and house against the negative shape of the sky simplified the composition.

theory based on research. There are other theories as well, but like everything in art, these theories have to be tempered with judgment. There *are* masterful paintings with the primary interest dead center. Again, so-called "rules" in art should be respected and practiced, but also challenged. Look at the work of Pierre Bonnard and Roger Mühl.

The viewer's eye goes to wherever the greatest contrast exists. The area that demands attention will contain the darkest dark next to the lightest light, the coolest color next to the hottest color, textured areas near quiet areas, the largest shape near the smallest shape. Be careful, though, not to have your center of interest shout, "Look at me!" Overstatement is often less meaningful than understatement. If you have

too obvious a center of interest, the story may be told too quickly and there will be nothing more to say. These kinds of paintings may be attractive at first glance, but fail to hold interest.

Like a good novel, you don't want to know that "the butler did it" in the first paragraph. It is much more involving to discover events en route and to continue revisiting the story.

I think that is the magic of watercolor. It "suggests" rather than tells.

Don't start to paint before you are satisfied with the composition. Have you created well-defined space divisions? Do the shapes relate to each other dynamically? Is there *one* dominant shape and is it placed in a handsome area of the rectangle?

Obidos, Portugal

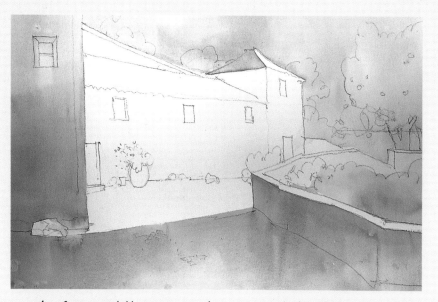

1 *The first middle-tone wash connected the sky, foreground, building, cast shadow, and stone wall. Colors of raw sienna and purple were mixed on the paper wet-in-wet. The middle-tone value crested the light value shapes of the building in the center and top of the stone wall.*

Look at how this composition was designed. The raking sunlight on the stucco texture of the building was the dominant element in this painting. The diagonal thrust of the foreground wall balances the diagonal of the roof of the building. The vertical section of the cropped building in the foreground, the wall, and its cast shadow combine to form one shape that forms a natural frame for the center of interest.

Interest is created in this shape with subtle color changes. Dynamic color changes are evident in the sunlit area. Employing design principles helps to build strong paintings.

2 *Rich washes of cadmium red, alizarin crimson, burnt sienna, and raw sienna were applied to the front of the house where I wanted the greatest contrast in color, value, and texture. I skipped along the roof with a 2-inch flat brush to indicate the tile texture. Dark green trees with changing edges were indicated behind the house.*

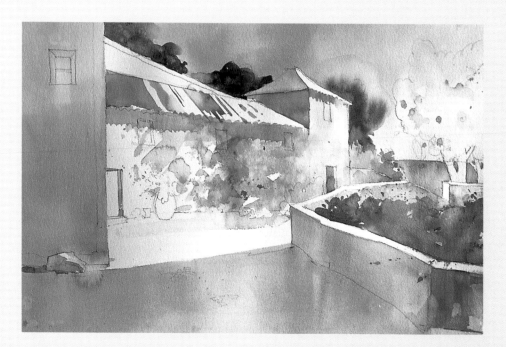

3 When I was satisfied with the middle-tone values (relationships?), I indicated the darks of the orange tree and shrubbery behind the wall as well as the large terra cotta pot and plant.

BELOW
Obidos, Portugal
15 x 22" (38 x 56 cm)

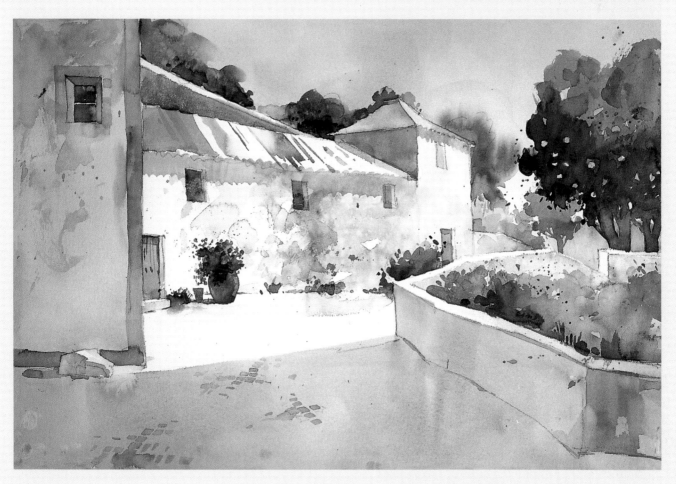

4 In this last phase of the painting, I suggested the reddish stripe of the edge of the foreground building, the recessed window, and a minimal indication of cobblestones.

The Shape of Things to Come

One of the elements of design that is of great importance in the creation of art is shape. Shapes and their relationship to one another form the abstract pattern in any painting, regardless of how you paint or what you paint. When the great revelation occurs and you begin to "see" subject matter in terms of its shape and the space that it occupies in the landscape instead of looking at a "nice" tree or a "pretty" house, you will be taking a big step toward understanding design. There are only five three-dimensional shapes that exist in nature and in man-made forms. They are the sphere, cylinder, cube, cone, and pyramid. A tree shape is a vertical cylinder. A house is usually a cube shape. Church steeples are cones or elongated pyramids. The human head is essentially a cube with a front, back, two sides, a top, and a bottom. You can paint or draw any three-dimensional form with authority once you identify its shape.

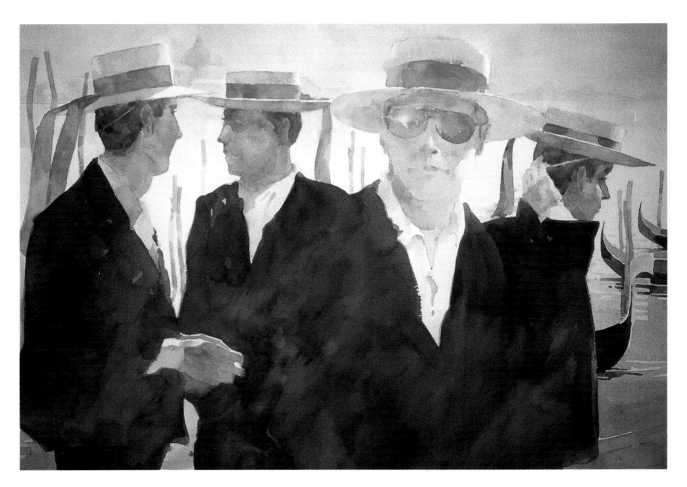

Gondoliers, 22 x 30" (56 x 76 cm)

One shape was created from the four shapes of the gondoliers' attire. The fewer shapes you have in a painting, the better. If a painting does not contain distinguished shapes, it will fail regardless of how well it is painted. Gondoliers *was honored by the American Watercolor Society with the Paul Schwartz Memorial Award and selected for the traveling exhibition of the 1997 American Watercolor Society show. It was also honored with the First Award and Medal at the 1998 Pennsylvania Watercolor Society Juried Exhibition.*

A shape becomes more dynamic when there are variations in its measures. The rectangle is more interesting as a shape than the square, and the elongated egg shape is more interesting than is its cousin the circle. Fewer and larger shapes make for a more powerful composition than many small shapes (see *Gondoliers* on opposite page). I refer you to the paintings of Andrew Wyeth, Fairfield Porter, or Diebenkorn for evidence of this observation. Many people admire Wyeth's painting for the mastery of his technique and detail. The more sophisti-cated viewer looks past his virtuosity to the dynamics of his paintings, which is the relationship of the shapes. And there are very few of them. At the conception stage you should begin to think of shape before color, value, texture or anything.

Shape is the beginning of things to come. If shapes are not distinguished, it doesn't matter how well they are painted. If there are too many shapes, combine them to form fewer. Or eliminate those that are small and meaningless. Vary them. Have one shape dominate. Simplify.

Bermuda Light, 15 x 22″ (38 x 56 cm)
(Collection of Chris and Marlene Marson)

The guts of this painting come from the chiaroscuro shapes of the high-key white roofs and the mid-tone value of the shadow area. The shadows were kept transparent and open. The mid-tones serve as a link between the darks of the foreground and the white roofs. Note the reflected light on the wall adjacent to the cast shadow.

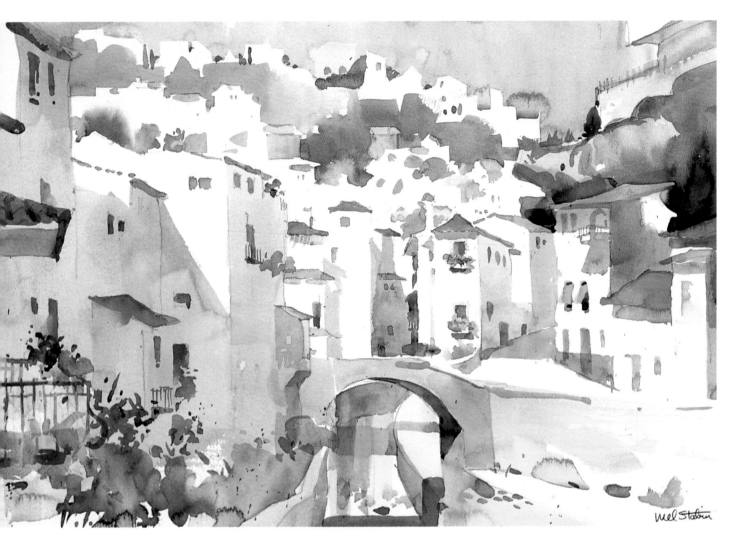

Sentinil, Spain, 15 x 22" (38 x 56 cm)

This painting of one of the "white villages" in Andalusia was a challenge in recording the busyness of the place. I did not get hung up on the multitude of details that I saw. I squinted hard and determined the large masses of shapes and values first. I then created the meandering white shapes of the houses with my mid-tone values. When I was satisfied with the relationships of the big shapes and values, I proceeded to indicate minimally some detail in the foreground.

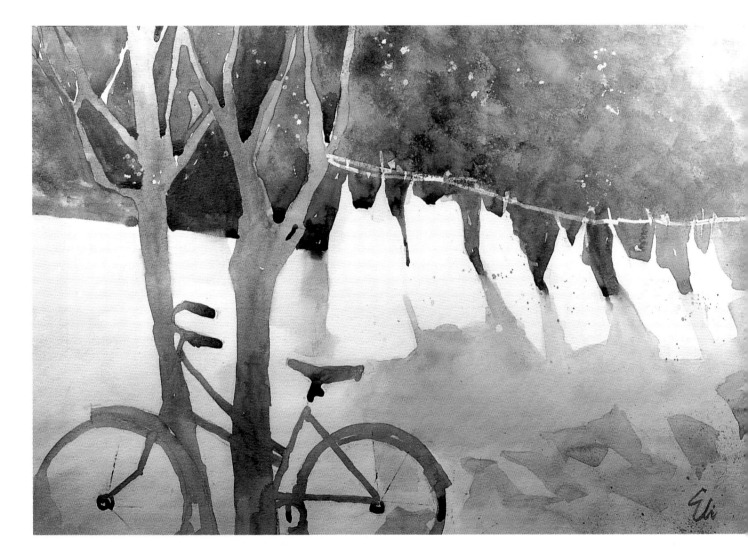

White Line BY ELI ROSENTHAL, 15 x 22″ (38 x 56 cm)

Combining the trees and bicycle into one shape created an interesting silhouette. Eli sees things in their simplest terms, as is evident in the painting of the background, white line, and foreground. Distinction of values helps clarity in this well-designed painting.

It's the Large Masses that Count

In all the watercolor workshops I conduct, great emphasis is placed on "seeing" and designing the large masses of shape, value, and color. It is the first step in the development of a successful painting regardless of the medium. All too often an artist becomes impatient with this first step, too eager to get to the subject at hand. If your objective is to create strong, dynamic watercolors, you should think about designing the large masses of your subject *before* you paint.

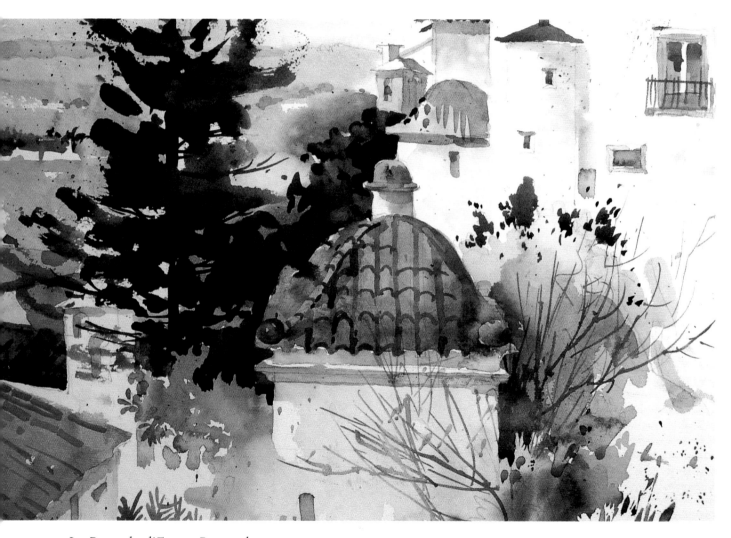

La Pousada d'Evora, Portugal, 11 x 15″ (28 x 38 cm), (Collection of Joan Balestier)

The lights, darks, and mid-tones are obvious. The dark pine tree makes the tiled roof of the foreground tower emerge and the dark mid-tone value of the tower roof overlapping the white shapes behind it dramatizes their value. The "lost" edges help to connect shapes. There is an impression of a lot of detail, but actually there was not much done to indicate it.

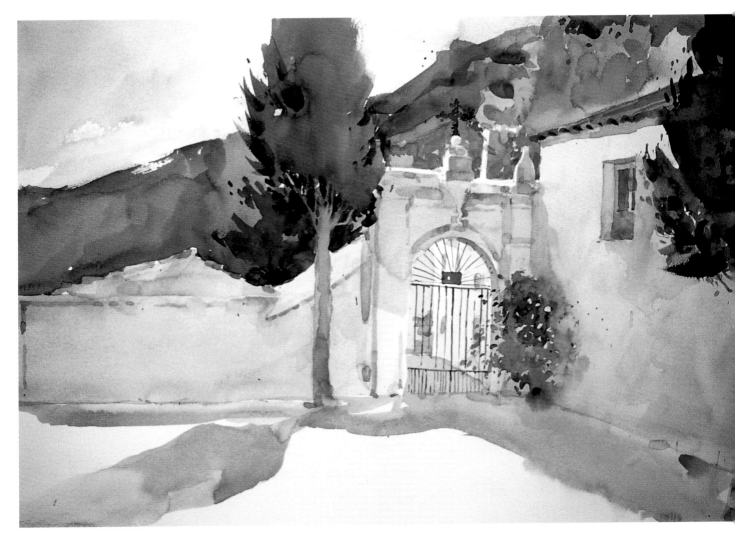

Zahara, Spain, 15 x 22" (38 x 56 cm)

I was struck by the diagonal shape of the white cemetery wall against the mountain ridge behind it. The architecture seemed very organic. The two cypress trees provide vertical conflict to the strong, cascading diagonals. Dominance is maintained through the light mid-tone of the contiguous shape of the wall, gate entrance, and house.

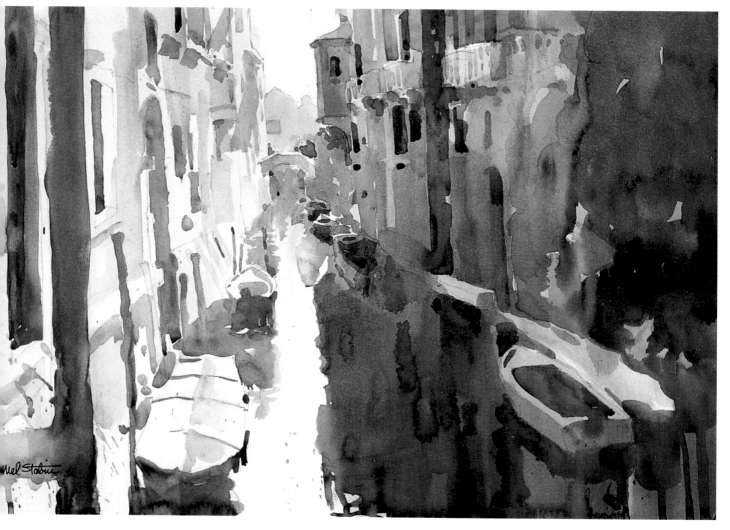

Reflections of Venice, 15 x 22" (38 x 56 cm)

Holding on to the identity of the large masses of value and color was paramount here. I successfully resisted the temptation to include "everything" in the painting. The power of suggestion can be very significant. The first applications of washes were "floated" in and allowed to mingle with one another. I then glazed colors into them, wet-in-wet, and watched the watercolor play. The suggestion of detail was put in when the big washes were dry.

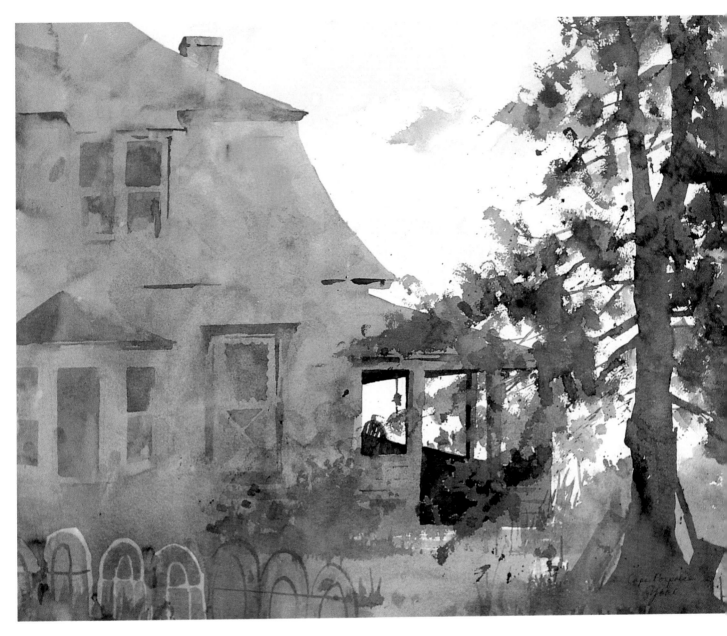

A House in Cape Porpoise BY YOKO WAKABAYASHI
18 x 22" (46 x 56 cm), (Collection of Mel Stabin)

This painting exemplifies perfectly the importance of emphasizing the large masses. The power and beauty of Yoko's work come from her intuitive sense of pattern. The grays are delicate mixtures of warm and cool washes that create a dominance in the mid-tone values. Details of doors, windows, and textures are suggested, not delineated.

How to "See" the Big Picture

Learning to "see" the large, simple masses of shape, value, and color becomes intuitive after some trial and error. It can be learned and like anything else requires some patience and discipline. Regardless of subject matter, "seeing" the large masses before you paint is of utmost importance. I do this by squinting a lot (which accounts for the "crow's feet" around my eyes). Squinting tends to eliminate the all too many small values, colors, and shapes of a subject and gets you to see the big picture. If the large masses are well designed, everything else will fall into place. Simplify values into just a few categories. Simplify shapes.

One big shape is better than three small shapes. Try to visualize the composition of the big elements in your painting. Do a few small, rough pencil sketches concerning yourself only with creating the simple, large, abstract shapes of your subject. Keep on squinting. You should train yourself to "see" beyond the subject. Do not just look at the literal "facts" before you—trees, buildings, sky, water, and so on. Translate what you see into a dynamic design of shape, mass, color, value, size, rhythm, harmony, repetitive themes, and so on. Through experience you will develop educated eyes and will begin to "see" instead of look at subject matter.

If only we could see the world through the eyes of a child, we'd all be better painters.

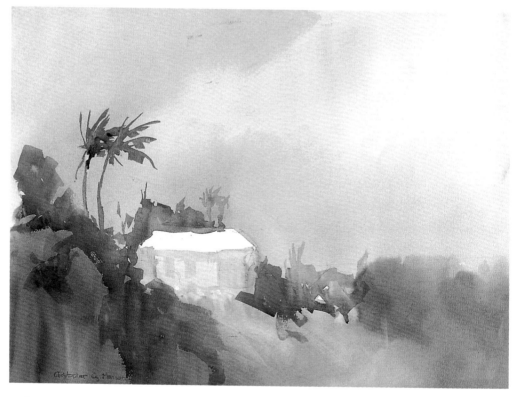

Storm at Jobson's Cove BY CHRIS MARSON
18 x 22" (46 x 56 cm)
(Collection of Mel Stabin)

This wet-in-wet painting captured the threat of the coming storm at Jobson's Cove, Bermuda. It occurred during one of my workshops and forced Chris to paint with lightening speed. A limited palette and confident brushwork resulted in this magnificent, understated watercolor.

Designing the Big Shapes

We tend to see too much. Combine small shapes and values in your composition to build a stronger pattern. It's the big masses that count. If they are not apparent in your subject . . . design them. Make one shape dominant.

When you are satisfied with the big shapes in the composition and their relationship to each other, do a small value pattern sketch (about 5 x 7"). This will be discussed in Chapter 3. The value study is sort of a road map for simplifying the large value shapes in the painting.

The large masses are the "bones" of your painting. It's the stuff that better paintings are made of, readily recognized in the works of the masters and in all valid paintings. Your technique or style of painting is your own, but consideration of the large masses of the painting transcends and is more important than individual style. Think big.

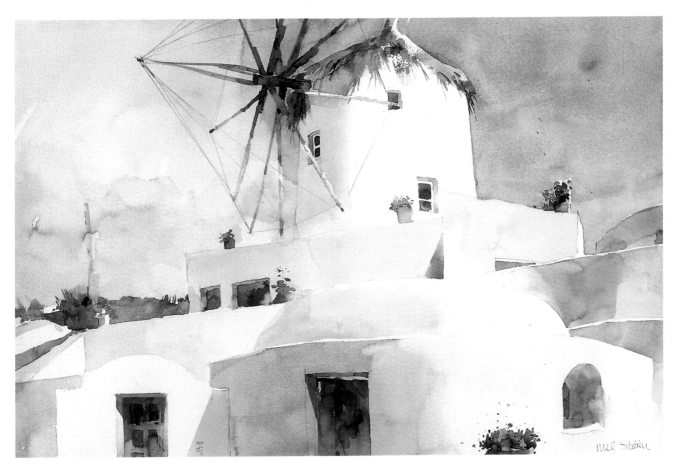

Santorini, 15 x 22" (38 x 56 cm), (Collection of Robert and Alice Demarest)

"Seeing" the large masses of value and color in the objects is far more important than seeing the objects themselves. Here the large masses are the big shape of white and the small darks against a mid-tone value. You have to resist the seduction of detail.

Treat Your Edges

When you focus on an object, the edges of that object are sharpest where the greatest contrast of light and shadow occur. The edges that fall into shadow are usually blurred or less distinct when they meet other shapes of similar value (see *The Stone Mason*, page 48). These "lost and found" edges, when employed in a painting, help to create the illusion of a three-dimensional form. There are three edges that your brush can make: a hard sharp edge, a soft or diffused edge, and a rough or dry-brushed edge. These edges offer variety in the marks that they make. A sharp edge is the most aggressive mark and usually makes a shape appear to come forward. A soft edge has the most amorphous quality and makes a shape recede. A dry-brushed edge usually suggests activity or detail.

When aggressive, warm colors are combined with a defined edge or cool recessive colors with a diffused edge, they tend to heighten the impression of reality. The sharp-edged warm colors can describe details in the foreground areas, while soft-edged cool colors can describe distance.

Observe the paintings of the masters. Rembrandt and Vermeer oblige you to see specific features of their subjects first by creating the greatest contrast of value and color in that area, and then directing your eyes to follow the light as it diminished into soft-edged, fused shadows.

In naturalistic painting, edges should not be all

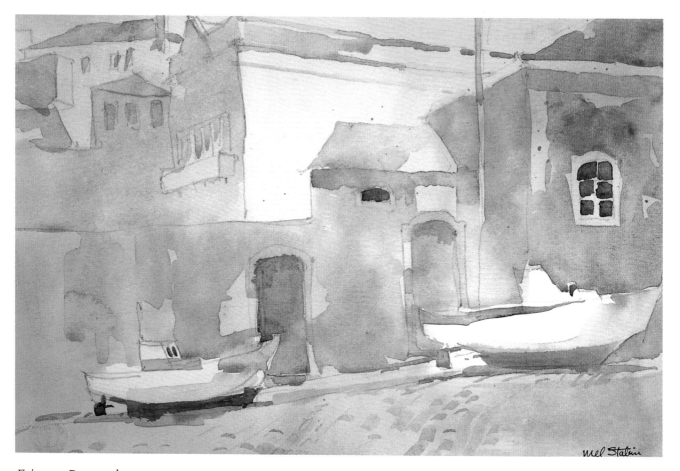

Ericera, Portugal, 11 x 15" (28 x 38 cm)

The mid-tone value of the buildings was conceived as one large merged shape of color. Note how the foreground wall loses its edge against the buildings behind it. The "defined" edges are indicated where the sunlit side of the building meets the shadow side and in the white boats.

Asparagus and Friends, 11 x 14" (28 x 36 cm)

Lost edges occur between the lemon and its cast shadow, some of the whites in the mushrooms, and the shadow side of the asparagus. The sharp edges are seen where the greatest contrast is, like the right side of the asparagus bunch against the background.

sharp or all soft, but a combination of both.

These edge effects are similar to the way your eye or the camera sees form. When you critically focus on an object, that area is sharp. As values recede from that object, peripheral edges become less focused or begin to blur (see *The Chesapeake,* page 49). This methodology is not the only way of working. There are wonderful hard-edged paintings where the concern is not to vary edge treatment, but to place great emphasis on shape. There are also artists who only paint diffused canvases to make a more ethereal subjective statement. Think of the paintings of Turner.

To create a hard edge, load your brush with a balance of pigment and water, depositing a sharp mark on dry paper.

To create a soft or diffused edge, apply paint onto wet paper or lay down a sharp edge and then diffuse that edge by applying clear water to it with one swipe of your brush coming from white paper and going to the color.

A rough-brushed edge is made by moving a loaded brush quickly across the paper (the brush should have just enough water to allow the color to flow), depositing pigment on the hills of the paper and not in the valleys. A "toothed" rough or cold-press paper is best for creating the rough-brushed mark.

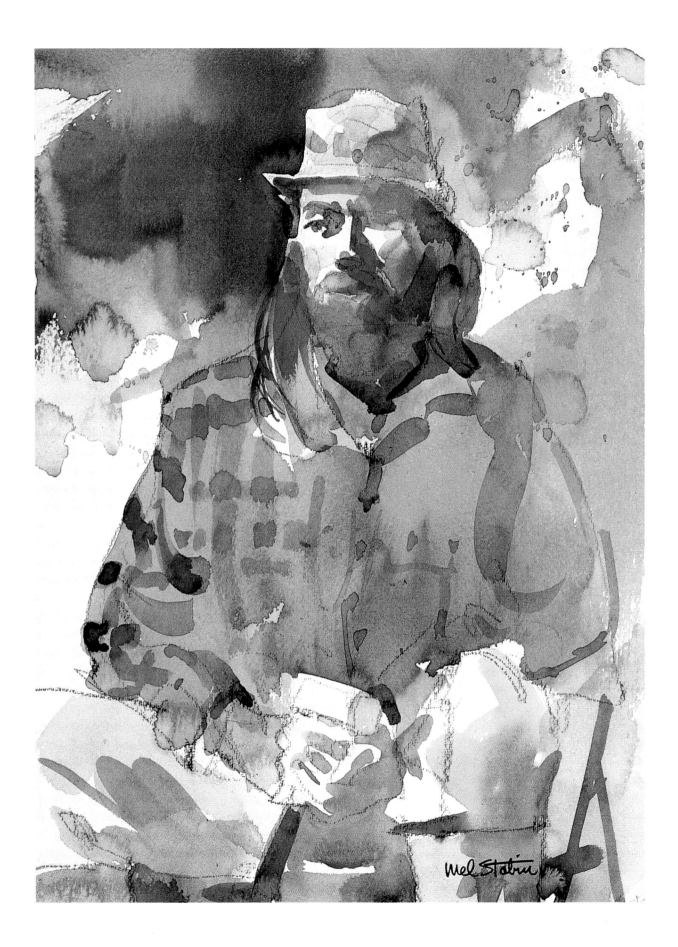

OPPOSITE
The Stone Mason, 15 x 11" (38 x 28 cm)

Losing definition of the shirt by fusing it into the background created harmony. Primary interest is in the face, where the strongest, sharp-edged contrast in color and value is evident.

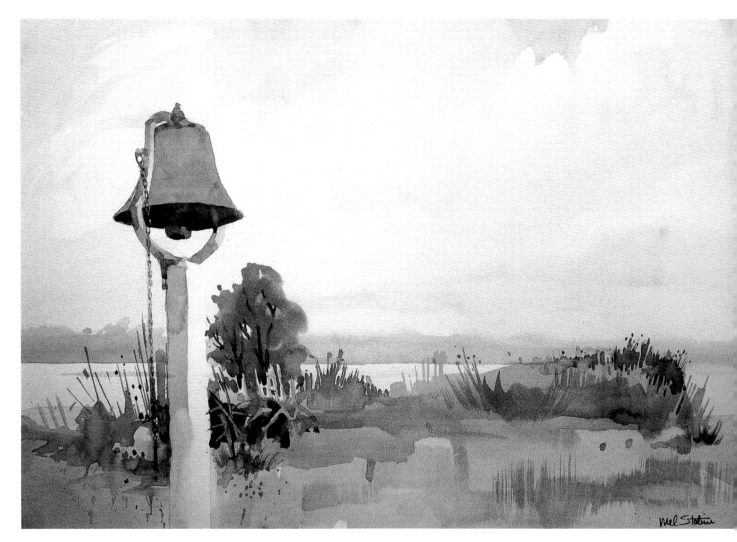

The Chesapeake, 15 x 23" (38 x 58 cm)

The rhythm of the hard edge of the cloud at top right changes to an amorphous edge and then picks up sharply again to the left. The bell post gets lost in the sky. The edges of the foreground brushstrokes change cadence in their rhythm, as does the distant shore.

Value-Pattern Sketch for *Captain's Mansion, Block Island,* 5 x 7" (13 x 18 cm) (final painting on page 5)

The Five-Minute Value Pattern Sketch

Organize and Simplify Your Subject

The value pattern: it's invaluable.

The objective of keeping your painting simple is aided greatly by the use of a value pattern sketch. Establishing a pattern of values helps to simplify and organize the elements of your subject. To determine the large important shapes and values, half close your eyes (squint) to eliminate confusing detail and force the values you see into three major categories . . . lights, mid-tones, and darks. You can expand the pattern to five values if it is preferable—a light, a light mid-tone, a mid-tone, a dark mid-tone, and a dark. Think of this small value sketch (I do them about 5 x 7") as a miniature poster. Try this. Take three pieces of paper—a white, a 50 percent gray, and a black—and cut shapes from each that represent your subject matter. The results will be very clear. It seems simplistic, but it requires some experience to accomplish this way of "seeing." Again, we see too much and are obliged to eliminate the small, insignificant values in order to make a simple, strong, clear statement.

Getting Started

I roughly sketch in the large shapes of the subject and then allocate values with a neutral color—ivory black or Payne's gray executed with a flat 1-inch brush. A pencil or pen can also be used for value studies, but I prefer the broad simple stroke of a brush. It covers an area quicker. The old masters often used sepia color for their sketches, and some artists employ two colors, a warm and a cool color. It's a matter of preference. I like the simple neutrality of a dark gray. I am not concerned with accuracy or detail at this stage. The focus should be only on establishing a pattern of lights and darks. Experiment with several different value sketches until you arrive at one that is expressive of your subject. All of the organizational thinking concerned with values, shapes, and spatial relationships goes into this sketch. This semi-abstract sketch determines the "bones" of what will become the painting. The value pattern sketch should take about five minutes or so to do. It is without doubt the most valuable five minutes of your painting experience. An unsuccessful painting is often the result of an unsuccessful value pattern.

Value-Pattern Sketch for *Chadds Ford House*
5 x 7" (13 x 18 cm)

My only concern here was to be very clear about the pattern of lights, darks, and mid-tones. No attempt was made to report texture of stone, stucco, foliage, and so on.

Chadds Ford House
15 x 22" (38 x 56 cm)

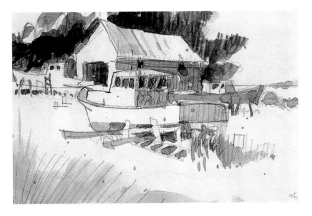

Value-Pattern Sketch for *Monterey Boatyard*
5 x 7″ (13 x 18 cm)

Again, focusing on the value pattern of this busy boatyard helped me to simplify the task at hand. I disregarded the many small values that I saw and forced them into three large, basic values. The value pattern is the support that the painting rests on.

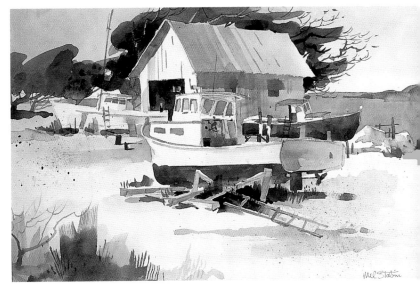

Monterey Boatyard
15 x 22″ (38 x 56 cm)

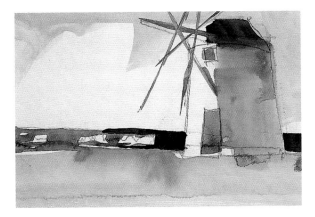

Value-Pattern Sketch for
Portuguese Windmill
5 x 7″ (13 x 18 cm)

After organizing the value pattern I was free to think about color, texture, and so on. The value pattern "road map" gave me one less thing to worry about when painting.

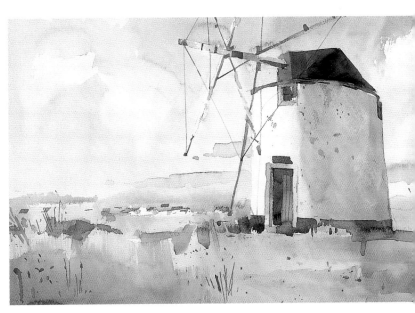

Portuguese Windmill
15 x 22″ (38 x 56 cm)

The Importance of the Mid-tone Values

Think of the mid-tone values as a cake, and the light and dark values as the icing on the cake. If the cake doesn't come out well, it doesn't matter how much icing it has on it. It's still a bad cake. I use this analogy to stress the role of the mid-tones. These values are the glue that holds the lights and darks together. They facilitate the transition or gradation of the light values to the dark values, and usually comprise the largest area of the painting. The best paintings have a distinguished pattern of mid-tone values. The mid-tones help create harmony in a painting, as opposed to light and dark values that create contrast.

My usual method of painting is to establish the light shapes with the application of the mid-tone values. I do not move on to the darker values (the icing on the cake) until I am satisfied with the shapes, color, and value of the mid-tones in the initial washes. It may be necessary to apply darker second washes to areas (glazing) or to lighten areas of the mid-tones that have gotten too dark. It is important to maintain the integrity of the mid-tone value and not to allow it to enter the light or dark values too quickly. The value gamut of the mid-tones runs from about 30 to 65 percent.

Morning in Cape Porpoise
15 x 22" (38 x 56 cm)

I did this painting at a workshop demonstration in Cape Porpoise, Maine, to emphasize to my students the role of the mid-tones. The sky and shadows on the house were conceived as one connected mid-tone value. This declaration of a large mid-tone shape assures unity. The lights and darks are secondary. Blue is the dominant color.

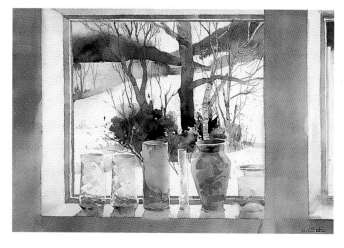

Winter Meadow
15 x 22" (38 x 56 cm)

The mid-tone value of the wall and vases on the windowsill frame and connect the lights and darks of the exterior scene. The quiet mid-tone of the wall contrasts nicely with the stronger values of the vases and exterior.

October at
McDaniel's Farm
15 x 22" (38 x 56 cm)
(Private collection)

The strength here is in the mid-tone values. The drama is in the wet reflective road, but it is the relationship to the mid-tones that allows it to shine. My greatest effort is always put into establishing just the right chord in the mid-tones and their relationship to the lights and darks.

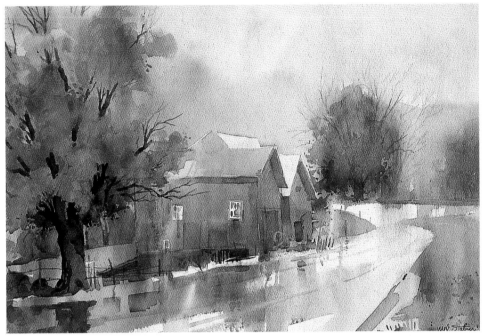

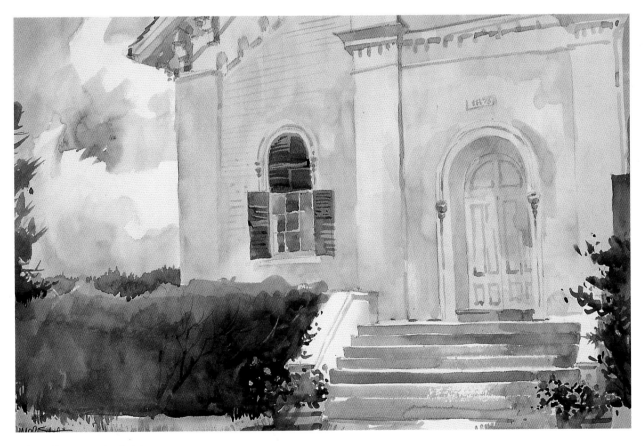

Church in Waitsfield, Vermont, 15 x 22" (38 x 56 cm)

Do you recognize the importance of the mid-tone values in this painting? Is the value pattern clear? Were shapes simplified? If the answer to these questions is "yes," you're beginning to "get it."

Color

Keep It Simple

In the arts, nothing expresses our personality more than color.

When we were children our art teachers taught us that the sun is yellow, the sky is blue, tree trunks are brown, and leaves are green. Though this early learning may seem simple, naïve, and not necessarily correct, there is validity to it in that all objects have a definite color identification.

As artists, we translate our individual reaction to color with paint. The science of color and paint has become quite sophisticated over the years.

This chapter is intended to help you understand color and its components in its simplest form. It will explain the color wheel, definition of color terms, color harmony, color complements, and the need to change color.

L'Artiste de Provence
15 x 22" (38 x 56 cm)
(Collection of Yoko Wakabayashi)

Color: It's a Personal Thing

We all react to color on a very personal level. It provokes a different emotional response from each of us. Color is "felt"; it is not a cognitive process. You certainly need to acquire an understanding of color, its properties, and potential in order to paint, but beware of getting overly involved in the mechanics of color. Keep it simple is the best advice I can offer.

The Impressionists were the first to expound on their affection for color. Cézanne and Monet represented the sensation of light with color and Van Gogh's irreverent, exciting masses of color led the way. The Impressionists reacted to nature with their "impressions" of color rather than to actual color.

Monet said, "When you go out to paint, try to forget what objects you have before you, a tree, a house, a field, whatever. Merely think, here is a little square of blue, here an oblong of pink, here a streak of yellow."

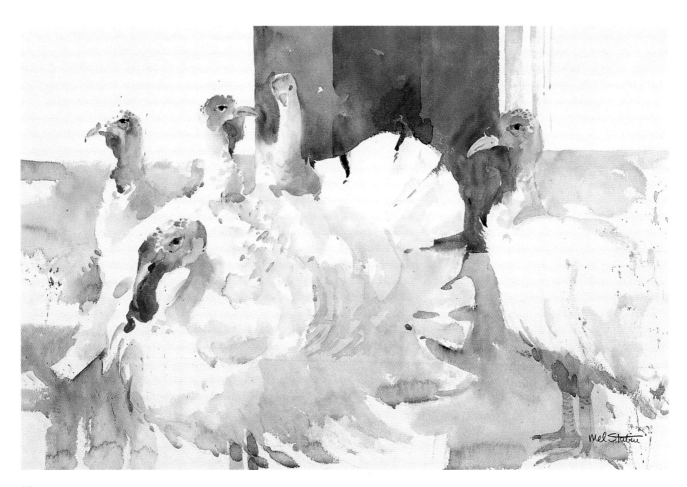

Tom, 15 x 22" (38 x 56 cm)

These white turkeys were painted at a farm near my home. I connected some of the white shapes and kept the values and colors of the shadows simple and subtle to emphasize the turkeys' cadmium red heads. "Big Tom" was very protective of his harem and did not approve of my presence.

Italian Villa
15 x 22" (38 x 56 cm)

The hot colors of the buildings and roofs could have been chaotic if it weren't for the quiet mid-tones of foliage between and around them. The mid-tones are the glue that cement the pieces of lights and darks together. Note the extension of the white in the buildings .

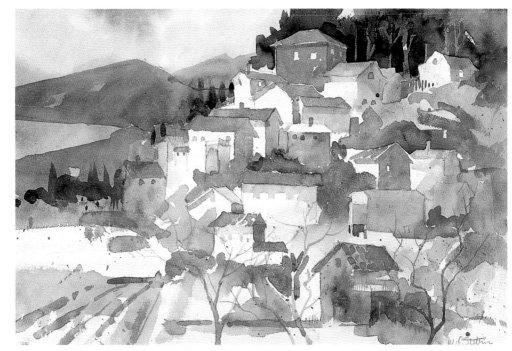

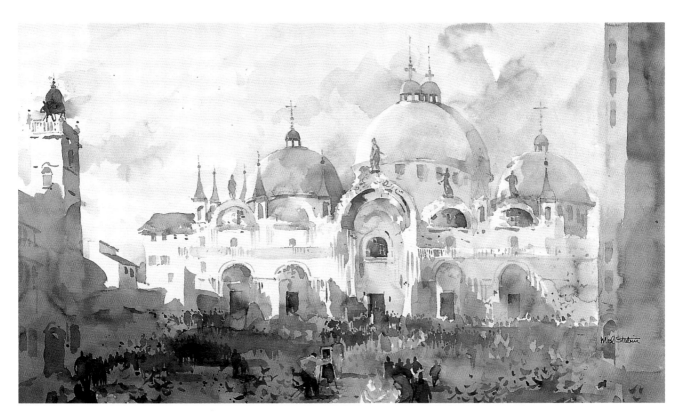

St. Mark's Basilica, 11 x 30" (28 x 70 cm)

When the sun begins to drop in Venice, magic happens. The façade of the basilica becomes a kaleidoscope of Byzantine color. I played hot and cool intense colors against each other to dramatize the event. The color may have been overstated, but that's how I experienced it.

Color Simplified

Sometimes too much information is too much information.

This color wheel illustrates the basics of color. It is made up of three primary colors: yellow, red, and blue (colors that are pure in their own state); three secondary colors: orange, purple, and green (mixtures of the primaries); and three tertiary colors (mixtures of a primary and a secondary color). Though each mixture of secondary colors and tertiary colors maintains some of the identity of the parent colors, intensity is lost. Many artists use secondary or tertiary color schemes for a "grayer" character in their paintings. Other artists enjoy the brilliance of primary colors.

If you want to investigate color potentials further, you can create endless combinations of primary with secondary colors, complementary colors, split complementaries, triads, and so on. Just remember you are not a scientist, you are an artist and you don't want to clutter up your brain at the risk of thwarting your senses.

It seems that every week new colors appear on the market—from metallic golds to neon pinks to colors that defy pronunciation. When you are comfortable and confident using basic color combinations, then certainly I encourage you to investigate and experiment with color. Do keep in mind, though, that you need not go beyond the theory of this simple color wheel to produce creditable paintings, or perhaps a masterpiece.

Definitions of Color Terms

· **Hue** The family name of a given color.

· **Value** This term refers to how light or dark a color is.

· **Temperature** Warm or cool.

· **Chroma (intensity)** Describes how bright or dull a color is.

Being aware of these definitions will help you to resolve problems in your paintings.
For instance, you may have used the correct color (hue), but was it the correct value or intensity?

Color Wheel

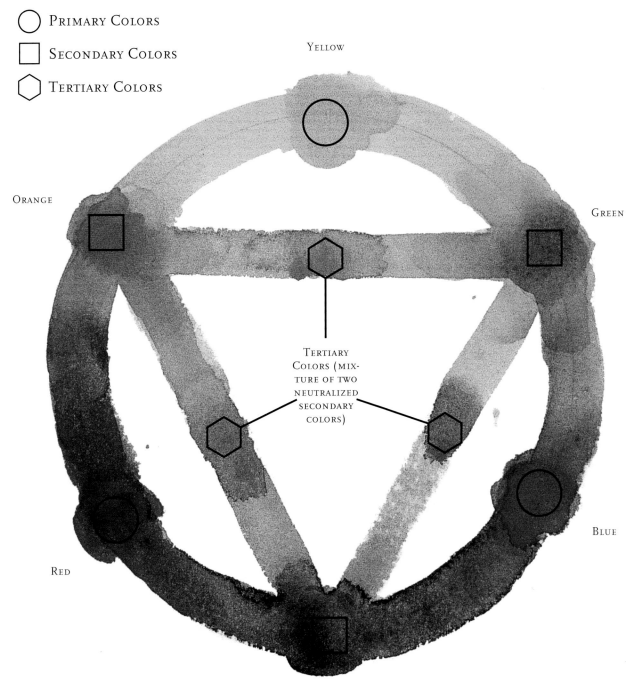

Primary Colors

Secondary Colors

Tertiary Colors

Yellow

Orange

Green

Blue

Red

Purple

Tertiary Colors (mixture of two neutralized secondary colors)

Color Harmony

To achieve harmony of color, employ an analogous color scheme, colors that go around the color wheel, not across it. Choose colors that are of a family such as red, orange, and yellow or blue, purple, and red. Any subtle variation of these colors will help to create harmony. A strong complement as a minor note to the chosen analogous color scheme will key or dramatize the harmony in a painting. Jean-Baptiste-Camille Corot employed this idea in many of his paintings.

Repeating a dominant color throughout a painting can create harmony. The echo of a color creates links that tie shapes together. An underwash of a color over the entire paper can serve as a harmonious foundation in a painting into which subsequent washes are imposed.

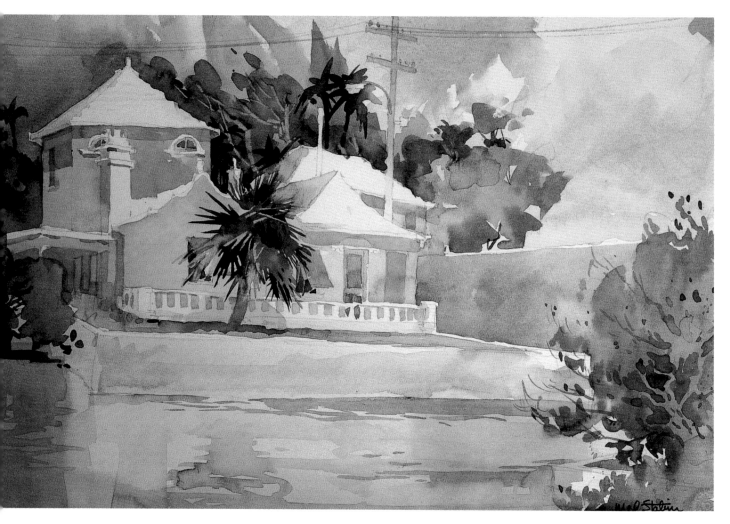

Aqua Reflections, 15 x 22" (38 x 56 cm), (Collection of Susan Bethke)

Harmony is created by the dominance of blues and purples. The dulled greens in the foliage act as a backdrop to project the intensity of the blues and purples. The subtle yellows that appear in the windows, doors, and trunk of the foreground tree do not threaten the harmony of the other colors.

Taos
15 x 22" (38 x 56 cm)

The analogous colors of the yellow adobe and warm green trees harmonize. The subtle kiss of purple in the shadows excites the yellows of the house.

Cape Porpoise, Maine, 15 x 22" (38 x 56 cm), (Collection of Charlotte Bollinger)

The neutral tints of color and mid-tone values link together the elements of the painting. Echoes of the color in the marsh are found in the railing and light bounce in the left wall. The deep orange in the lobster markers near the top left corner creates some excitement against the blue complement of the porch.

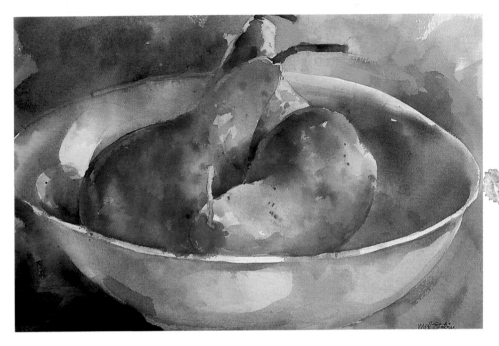

Three Pears
15 x 22" (38 x 56 cm)

The two secondary colors of purple and green and one primary, yellow, creates harmony in this still-life painting. The primary color blue exists in both purple and green. Yellow exists in green and is the complement of purple. These "links" connect the various elements.

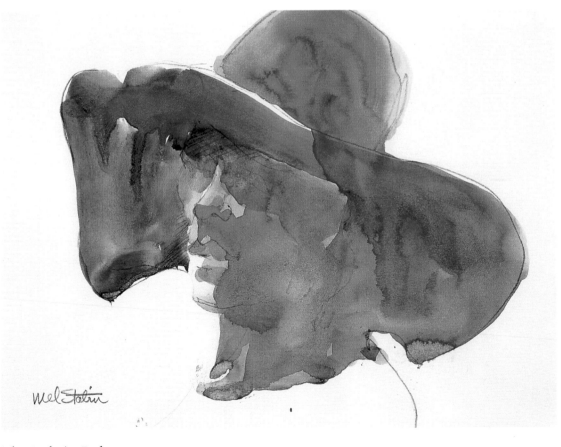

The Lady in Red, 7 x 9" (18 x 23 cm)

Dripping, wet-in-wet washes of hot and cold reds, purples, and blues dominate this portrait sketch. The introduction of raw sienna in Bobby's right eye socket creates a delicate relief from the dominance of the reds.

Cape Porpoise Fog
15 x 22" (38 x 56 cm)

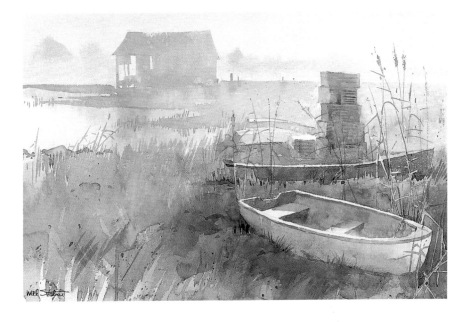

This painting was started at 7:00 a.m., just as the sun cut through the morning fog. The broad gradation of pale green in the distance to darker, richer greens in the foreground was the foundation for harmony in the painting. The mood of fog (a favorite subject of mine) is expressed by the rapid recession of color, value, and texture from foreground to background.

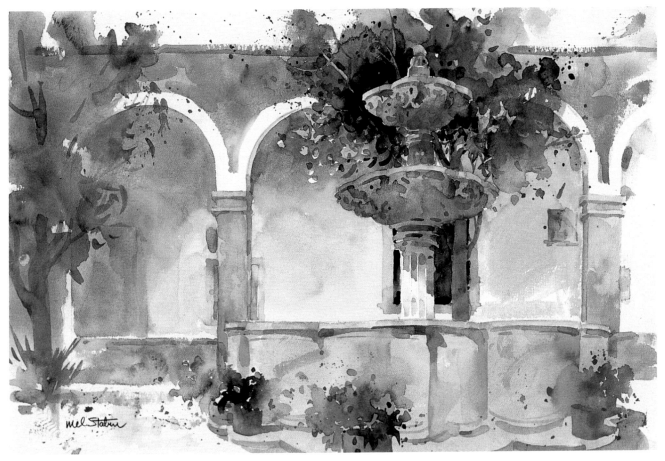

Courtyard in San Miguel, 15 x 22" (38 x 56 cm)

Employing three secondary colors of orange, purple, and green helped to create a sense of harmony. The colors of Mexico are often intense, primary colors and one must use restraint for a subtler approach.

Color Complements

Colors that appear across from each other on the color wheel are complements. When complements are mixed together they neutralize each other and create a gray color. When complements appear next to each other, they tend to excite each other. A small pure area of intense (primary) color near a larger area of its complement will create a strong dynamic of those color shapes.

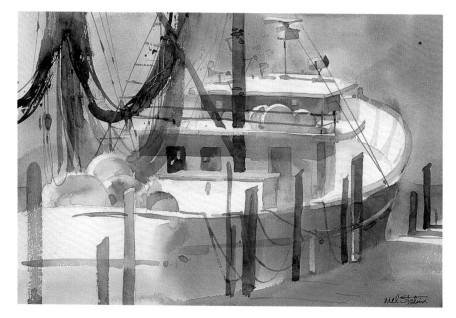

Shrimper, 15 x 22" (38 x 56 cm)

The imposed purple dominance was designed as a complement to the yellow floats. The inspiration was the jewel-like quality of the floats affected by the strong sunlight. There was a great deal of texture and color on the boat that I subdued to emphasize the "idea" of the painting.

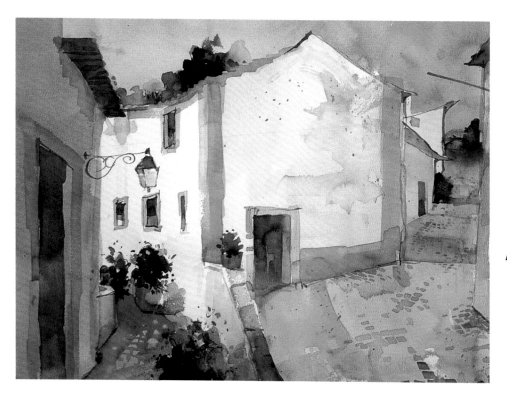

Cobbled Streets, Portugal
15 x 22" (38 x 56 cm)
(Private collection)

Many of the white homes in Obidos, Portugal, are decorated with wide stripes of deep yellow or ultramarine blue. The intense yellow/orange dictated its counterpart purple/blue in the sky, cast shadows, and foreground building. Note the variety in treatment of the cobblestones.

Springtime in Paris
11 x 15" (28 x 38 cm)
(Collection of Betsy and
George Wick)

The pink lips on the kiosk and the distant red canopy offer a complement to the dominant rhythm of the green tree foliage and the green canopy to the right.

The Green Canopy, 15 x 22" (38 x 56 cm)

The secondary colors of green and purple dominate, with the complement of yellow at the entrance. When painting with complements, have one of the colors dominate the others—either in size or intensity.

Change Color

Interest in an area is gained by variety. Change creates variety. Change is the antithesis of stagnation. Think of your brush as a chameleon changing color every few inches. Change in color can be subtle or aggressive. That is contingent upon your own sensitivity and the needs of the painting. Change breathes life into your work, especially in the darks. Dark interiors of doorways and windows are often interpreted as appearing black and flat. If they

All Kinds of Flowers, 15 x 22" (38 x 56 cm)

Subtle color changes occur in the light and dark passages. The top of the vase has soft fusions of lemon yellow, alizarin crimson, yellow ochre, and a warm gray to echo the colors of the flowers and to report the texture of the vase.

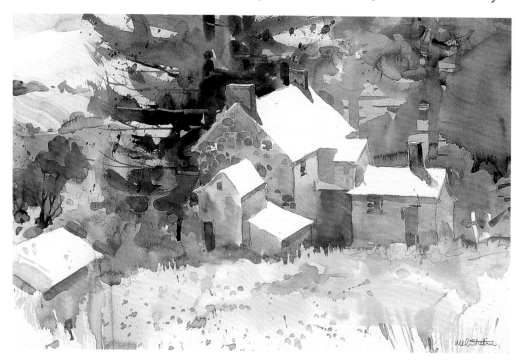

Wiley's Farm, 25 x 22" (38 x 56 cm)

Mr. Wiley, a neighbor and friend of Andrew Wyeth, allowed my students to paint on his farm in Chadds Ford, Pennsylvania. Color was vigorously changed to express the joy I felt about the day and the location.

are painted that way, they usually result in a sullied, lifeless, dull color. To avoid this and to create interest in the area, a good rule to follow is to change color when there isn't a change in value. A rich mixture of dark colors (mixed on the paper not on the palette) will give vitality to a dark value. To avoid opaqueness, I often employ at least one or more dye colors to create a rich transparent dark. If some of the dark shape becomes opaque, don't fret. It's okay. It's even desirable at times. Opaqueness in small areas heightens transparency in the large areas. Look at Andrew Wyeth's watercolors. Often, large areas are dark and opaque, but they lend a sense of jewel-like transparency to the lighter areas. Wyeth also places great emphasis on value rather than color. He is not a "purist" and while he respects the medium, he does not regard anything as sacred if it gets in the way of the idea of the painting. Color changes should also occur in light and mid-tone values to create interest.

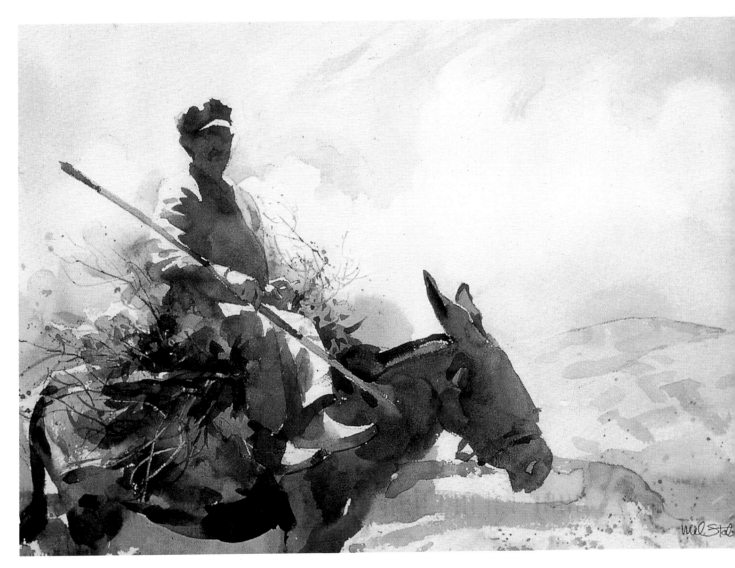

Mountain Farmer, Greece, 15 x 22" (38 x 56 cm), (Collection of Jean and Joe Hope)
Strong, intense color changes are stated in the flowers of the scrub branches, while less active color changes occur in the shadow of the farmer's body and on the donkey. Color changes should have a cadence to them.

Bermuda Pastels

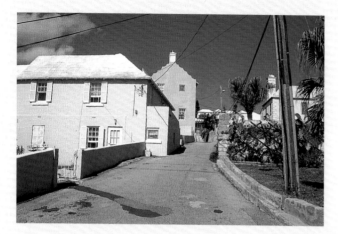

Street in St. Georges, Bermuda.

I would say that 95 percent of the watercolor paintings reproduced in this book were done on location or from life. *Bermuda Pastels* was a class demonstration I gave during one of my workshops in Bermuda. I photographed the various phases of the painting during breaks in the process. Two essences of Bermuda are pastels colors and light. I tried to capture these qualities by painting directly, simply, and as transparently as I could.

I never hesitate to exaggerate color or the sense of strong sunlight in Bermuda. Emphasizing the essence of anything is a good thing.

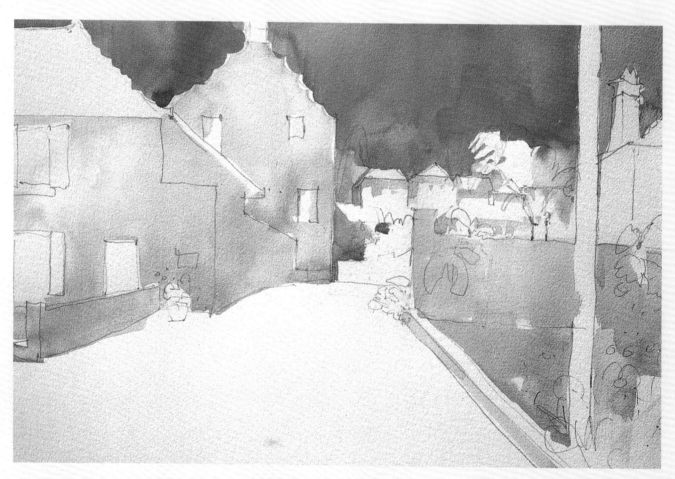

1 I applied light mid-tone washes of alizarin crimson, raw sienna, and purple (mixed from alizarin crimson and cobalt blue) over my sketch, leaving areas of white. The sky was made a darker mid-tone to help the pink house "pop."

1 I applied light mid-tone washes of alizarin crimson, raw sienna, and purple over my initial sketch, leaving areas of untouched white paper for the lights. The sky was made a darker mid-tone to help the pink house "pop."

2 The shadow shapes of the house and wall were then indicated as dark

Bermuda Pastels (BELOW)
15 x 22" (38 x 56 cm)

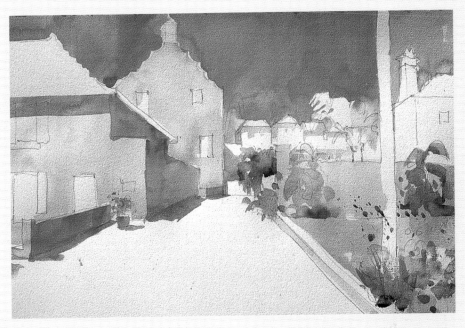

mid-tones. Some of the dark shrubs and trees were put in. I borrowed a hot pink plant from across the road and put it at the base of the telephone pole to balance the dominant pink house.

Significant Color

Before you begin a painting think about your emotional reaction to the subject. What is the "idea" that you want to focus on? When you know this you can consider "significant color" to express the "big idea." Do you want the color idea to be mostly warm or mostly cool? Will the attitude of the painting be representational or abstract? To reflect your emotional reaction to your subject, are you willing to paint blue skies orange and green trees purple? Is the mood of the painting to be tranquil (maybe best represented with analogous colors) or dynamic (maybe best represented with complementary colors)? The distillation of these questions asked *before* we paint will simplify and clarify our thinking when we begin.

Color communicates the emotion of a painting. It reflects our personalities more than any other element. Through color, the viewer will experience the dynamics of a painting, whether it is bold, sensitive, poetic, exciting, and so on. Passages of color can be used arbitrarily and intuitively for the sheer joy of it, but I believe they should be significant and expressive of subject matter.

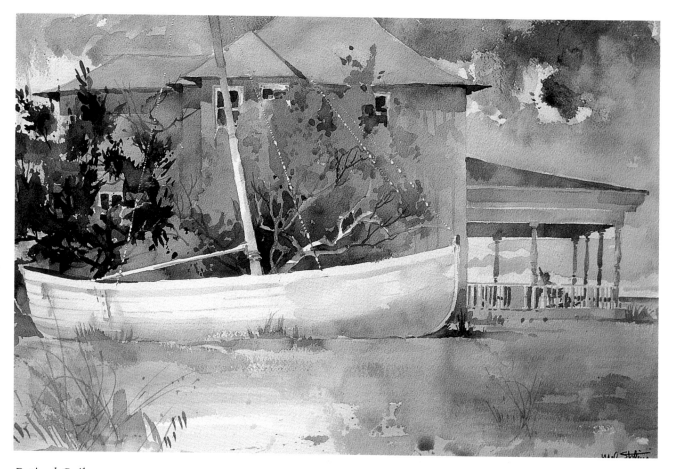

Retired Sailor, 15 x 22" (38 x 56 cm)

A limited palette of deep grays and neutralized greens was employed to express the mood of an approaching storm. Values were kept close except for the eerie light on the boat. A couple of dulled reds offer a relief to the dominant greens. It stormed just as I finished painting.

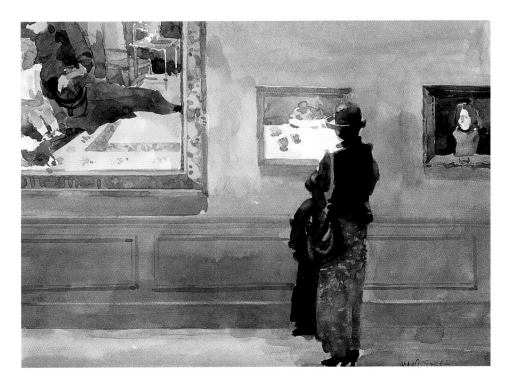

The Met
11 x 14″ (28 x 36 cm)

The solitude one experiences in an art museum is expressed here through the use of a harmony of colors and values. An analogous color scheme of red, yellow, and warm grays reflects tranquility. The warm colors repeat in the dress and shoulder bag.

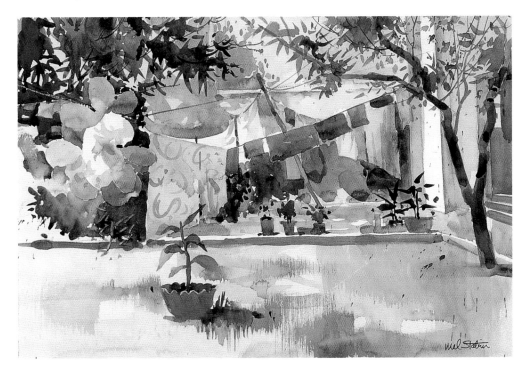

Colors of Mexico
15 x 22″ (38 x 56 cm)

The excitement of color in the festive balloons and clothesline represented for me the essence of Mexico. I tried to make the dark leaves of the trees "dance" with rapid flips of the brush. The foreground of quiet washes enhances the excitement elsewhere.

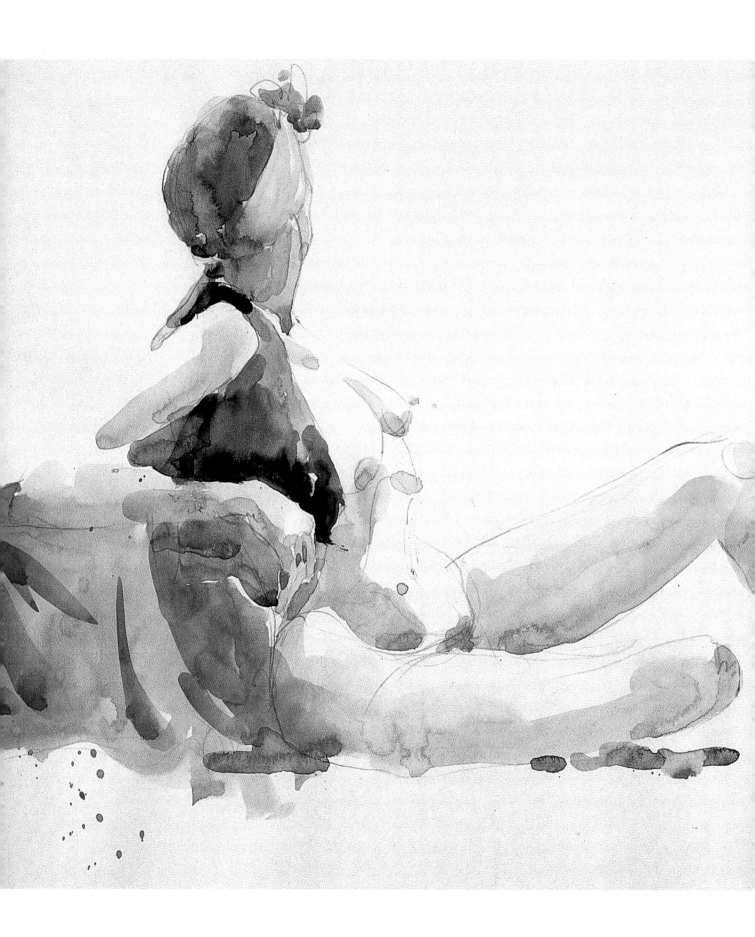

Painting the Figure and Portrait

What is more glorious to paint than a figure bathed in light?

Painting the sensuality of skin bathed in light and trying to capture the unique personality of a human being is a very different experience from painting an inanimate object. The figure's complexion, gesture, proportions, attitude, state of being—all of these pose a challenge for the artist. Knowledge of design principles, color, shape, value, composition, and relationships are required in painting the figure or any object, but I think that more sensitivity and understanding are needed in painting the figure.

Drawing (the first step) with a sense of ease, the short and long poses of the model, and painting the portrait will all be covered in this chapter.

Black Vest
11 x 15" (28 x 38 cm)

Drawing with Ease

If you are painting the figure in a representational manner, you *must* know how to draw. No matter how accomplished you may be as a painter, your painting will be less successful if it is not based on a foundation of sound drawing. I always suggest that artists who are new to figure painting should attend sketch classes, drawing the model as often as possible. It takes a long time and a lot of practice to learn to draw the figure with a sense of ease. Start paying your dues now. It's a great investment in your future.

At Pratt Institute, one of the exercises we did in class was to draw the figure without ever looking down at the paper. Contour drawing is a way of seeing the figure intensely and training your eye to observe it. Often the results are a little strange. A nose might appear where an ear should be, but, with practice, the eye and hand coordination become more certain. It is a great way to draw because you become very aware of shapes and there are constant surprises of discovery. The idea is to keep your pencil on the paper throughout the drawing without lifting it and to focus on the model as much as possible. Check your drawing occasionally to know where you are. Do not be concerned if your drawing is not accurate in the academic sense. The important consideration is to let the pencil meander and to be aware of shapes. Think of your pencil as a bloodhound, hesitating in some areas, sniffing around for the direction of the next line. Sometimes the line is very free and takes off to describe a form. Other times the line will pause, especially when there is an articulation or change of angle in the figure. Sometimes the line will combine two or more shapes into one, or isolate some shapes. Develop a rhythm in the linework. It should dance across the page.

Gesture drawing is a method that uses longer rhythmic linework to describe the form of the figure. The line is faster and the swing of the line comes from the elbow and shoulder in contrast to contour drawing, which is restricted to the motions of the fingers and wrist, as in writing. In gesture drawing several groping lines may be made before

you decide on the one that describes the form accurately. You should be aware of the relationship of the large forms of the figure, the articulation of the forms and where the forms intersect each other. It is much more important that your figure drawing be "expressive" rather than accurate.

Accuracy and correct proportion will eventually come with practice.

Cool, 7 x 5" (18 x 13 cm)

A black Pentel marker was used on hot-press paper.

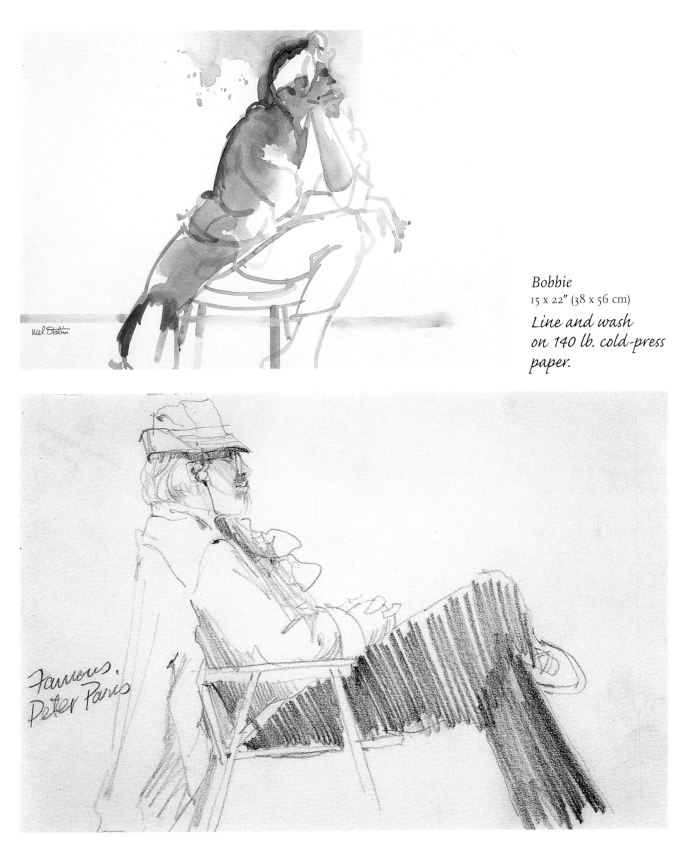

Bobbie
15 x 22" (38 x 56 cm)
*Line and wash
on 140 lb. cold-press
paper.*

Peter, 9 x 12" (23 x 31 cm)
Here a 4B graphite pencil on sketch pad was used.

Barbara, 14 x 11" (36 x 28 cm)
Charcoal pencil on bond paper.

Rob, 9 x 12" (23 x 30 cm)
Charcoal pencil and wash on Bristol board.

*A good painting
can never disguise
a bad drawing.*

Lost and Found, 14 x 11" (36 x 28 cm)
A 4B graphite pencil on bond paper was used.

OPPOSITE
Big Hands, 12 x 9" (30 x 23 cm)
*A black Pentel marker was used on bond
paper.*

The Short Pose

Any pose that is ten minutes or less is considered a short pose. In the one-minute pose, you will only have time to record the basic gesture and silhouette of the figure. Do ten of them in a row, let your brush fly, set yourself free. Do not hesitate. Your drawing will probably be off in these quick, short poses. Not to worry. Strive to "express" the gesture of the figure.

In the five-minute pose use one color describing only the shadow forms. Squint hard at the figure, increasing the contrast between the light and shadow areas. Soften some edges where the shadow enters the light area. Do not over soften the edges. Most of the shadow shape should remain hard edged. The ten-minute pose allows enough time for a more considered drawing and the use of a variety of colors. Color changes and fusion should occur as well as edge treatment.

Betty
II x I5" (28 x 38 cm)

This "quickie" of my dear friend Betty was executed with a limited complementary color scheme. Fast brush strokes and minimum delineation give the sketch its spontaneity.

One-Minute Figures
11 x 15" (28 x 38 cm)

Draw with the brush. Gesture and silhouette only. Don't worry about accuracy. Go for the rhythm of the figures. They should dance across the page. Have fun. Loosen up.

Three-Minute Figures
11 x 15" (28 x 38 cm)

I sketched quickly and just went for the shadow shapes, "squinting" all the time.

Ten-Minute Figures
15 x 22" (38 x 56 cm)

Here, I had enough time for some vigorous color changes. I used the three primaries and let the colors mix on the paper.

David

David is a serious young artist who posed for one of my classes. He felt a bit awkward and pensive because this was his first modeling session. I wanted to capture that feeling in his expression and contrast it with the relaxed pose that he fell into. Once I focused on what I wanted to express in my painting, I was ready to begin.

I felt my way through the drawing with a loose fluid line. I tried to develop a rhythm in the drawing, connecting shapes, simplifying form, and working quickly to avoid unnecessary detail, focusing only on the essence of what I was after.

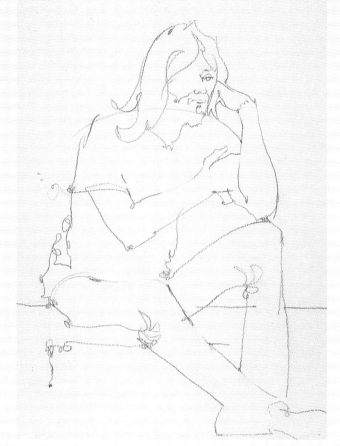

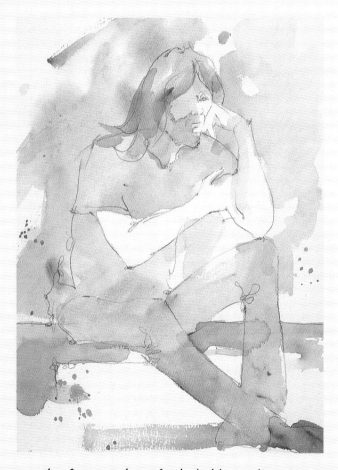

1 I began with a loose contour drawing (above). Some shapes were emphasized, some were combined, like the shirt and pants leg. The diagonals of the arms and legs made for an exciting pose. Notice how the background enters the figure in the lower back. Accuracy in proportion is essential if your approach is representational. The drawing should not be rushed, but don't dilly dally either. It is far better to be looser and spirited than detailed and tight.

2 The first washes of cobalt blue, alizarin crimson, raw sienna, and sap green were laid in quickly, allowing the colors to swim together. The figure is connected to the background in many areas. This is the phase of the painting that should be very free and joyful. I disregard the boundaries of the drawing to avoid "painting by numbers."

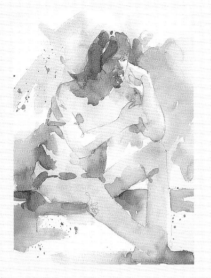

3 The major folds of the shirt and pants were indicated briskly. The shape of the pants is connected near the feet and to its cast shadow. This makes one shape out of three. The face and hair are indicated with lost and found edges. The colors of the face and the cast shadow are fused.

4 Stronger colors of cadmium red, raw sienna, cobalt blue, and burnt sienna were applied to the face, hair, and features. There was less emphasis put on the shadow areas of David's features. There is a sense of lost and found shapes throughout.

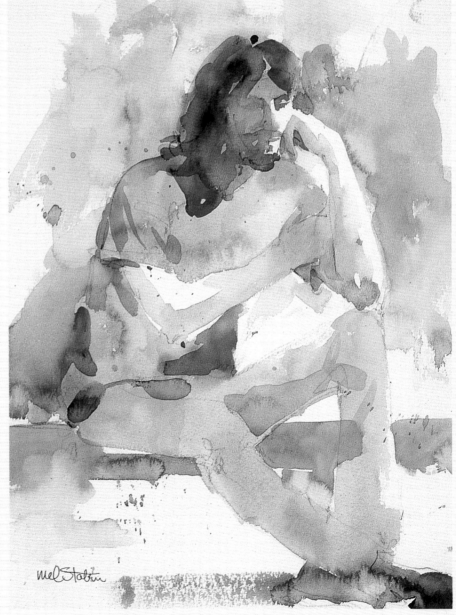

David
15 x 11" (38 x 28 cm)

The Long Pose

Twenty minutes is the usual time for the long pose before the model takes a break. A long pose can be a twenty-minute session or a series of twenty-minute segments of the same pose. Devote at least ten minutes or so to the drawing. If you need more time for the drawing, take it. It is important to have a good drawing that captures the spirit of the pose and is in correct proportion even if you do not have time to finish the painting. Determine the complexion of the model. A mixture of primary colors that I like for flesh tones is cadmium red light, cadmium yellow light, and cerulean blue. There are variations of these colors that you may prefer. Winsor red, raw sienna, and cobalt blue or alizarin crimson, raw sienna, and ultramarine blue for deeper values and dark skin are some other choices. Try permanent red or brown madder. Experiment. Most of the mixing of colors should be done on the paper. Do not over mix on the palette or the paper. Color should be deposited on the paper cleanly maintaining its iden-

tification. Homogenized colors turn to dull mud. Use warm reds at extremities . . . elbows, knees, nose, hands, feet, ears, or wherever you want a form to project.

Leaving the white paper to represent the light areas will heighten the contrast between the lights and shadows and tend to add crispness to the painting. A pale, warm wash applied over the entire figure can also represent the light area. When this wash is bone dry, the shadow colors are then applied with color changes, fusion of colors, and "lost and found" edges en route. Background shapes should be considered when painting the longer pose to place the figure in an environment.

Observe and exaggerate the sense of reflected light on the figure. This "bounce" light often occurs under the model's chin or breast. The reflected light should never be as bright as the primary light. It is a secondary light source that bounces off objects around the model into the shadow area.

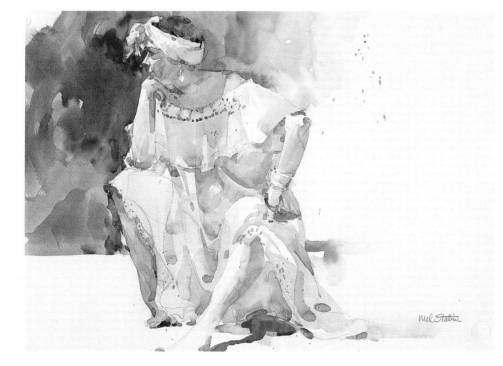

Bobbie in White
15 x 22" (38 x 56 cm)

When I understood the major folds in the lacy dress, I indicated them quickly and tried to avoid a stilted, studied look. I washed in some pale yellow ochre among the light blue and purple shadows to suggest a reflected light and the gossamer quality of the dress.

Julie
15 x 22" (38 x 56 cm)

The overhead light created wonderful shapes of light and darks. I used sap green (the complement of Julie's warm skin color) as my shadow color.

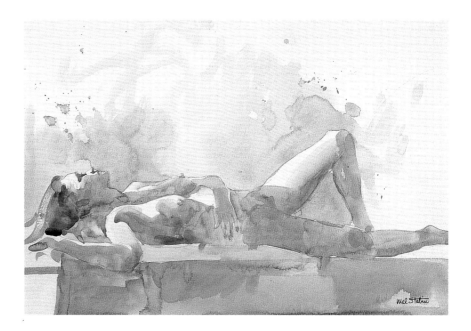

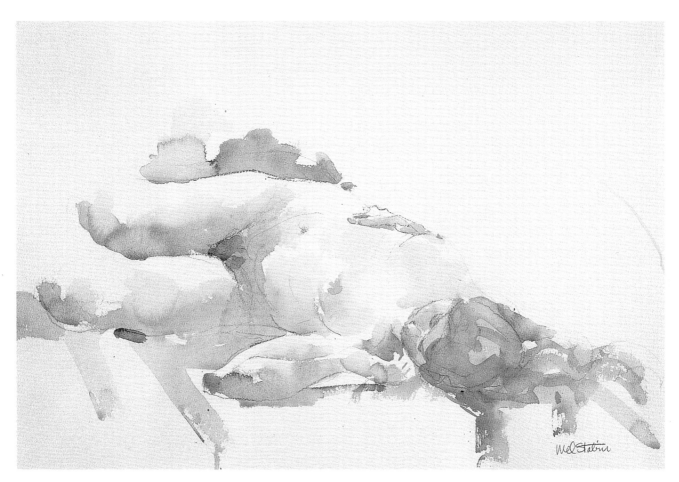

Fair-Skin Blonde, 15 x 22" (38 x 56 cm)

I wanted to describe the delicate skin of the model, so I kept the washes high key and allowed the lights to escape into the background.

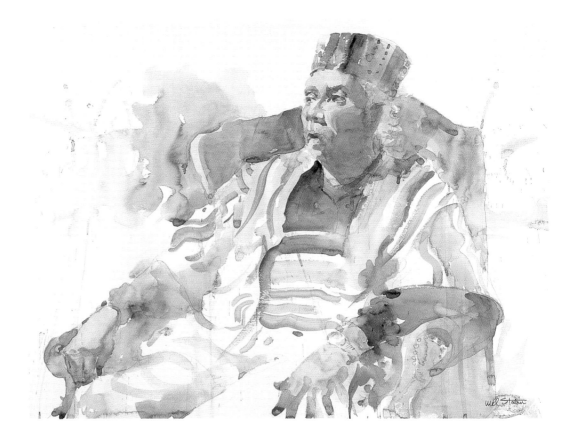

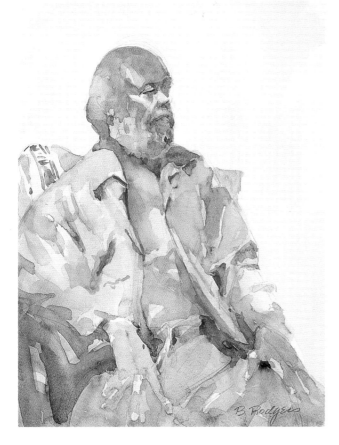

ABOVE

Mr. D, 22 x 30" (56 x 76 cm)

I tried to capture Mr. D's sense of dignity here, so I concentrated mostly on his facial expression. The vibrant colors of his attire were suggested with a minimum of detail.

LEFT

Gray Beard, by BEALL RODGERS, 16 x 11" (41 x 28 cm)

Beall's forté is glazing. There are few artists who do it better. The sensitive glazes throughout this painting are a result of many years of serious study and production.

OPPOSITE

Kwami, 15 X 11" (38 x 28 cm)

There was a regal attitude in Kwami's pose that was very commanding. I emphasized her erect posture to express her uniqueness. I also exaggerated color changes in her face for greater interest. I didn't want to indicate her brown skin color with just brown pigment.

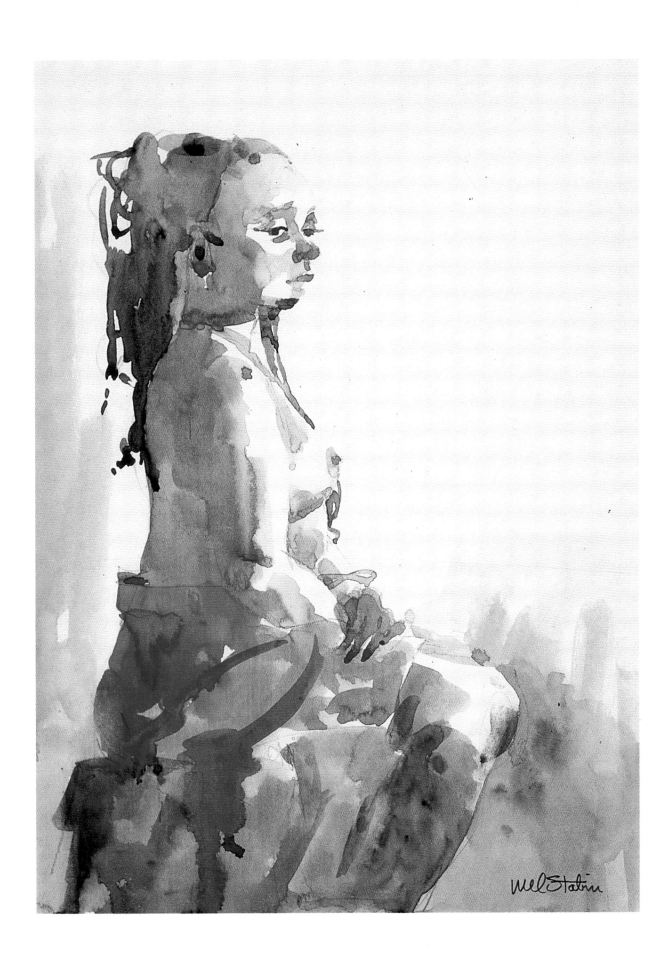

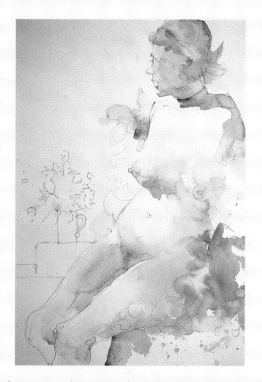

The Feather Boa

The chiaroscuro pattern of the model against the dark feather boa was very exciting to paint. I kept the washes on the figure simple, to contrast with the active silhouette of the boa. The feather boa was actually black, which I felt would have been too harsh against the model, had I painted it literally. The value of the boa was kept dark, but the color was varied to harmonize with the other elements of the painting.

1 After completing a loose contour drawing with a 4B pencil, I applied a variety of light, transparent washes to the figure describing only the shadow shapes. The lightest values are left paper white. Cerulean blue, alizarin crimson, raw sienna, and sap green were used for the color of the skin.

2 More definition is given to the structure of the model's head, features, and hair. A dark value delineates the boa and creates a strong contrast against the light side of the torso. A variety of hot and cold colors are splashed in for the flowers. The washes of changing color are continuous from the top of the head to the cast shadow along the shoulder, down the side of the body to the leg. Combining all of these shapes creates unity in the painting.

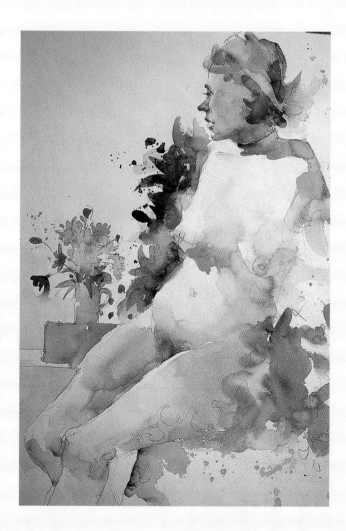

3 (Opposite) The feather boa to the right of the model is indicated as a large mid-tone value of analogous colors. Note the lost and found edges of the boa against the figure. I strengthened the warm color at the knees and emphasized reflected light on the model's right breast with a wash of raw sienna.

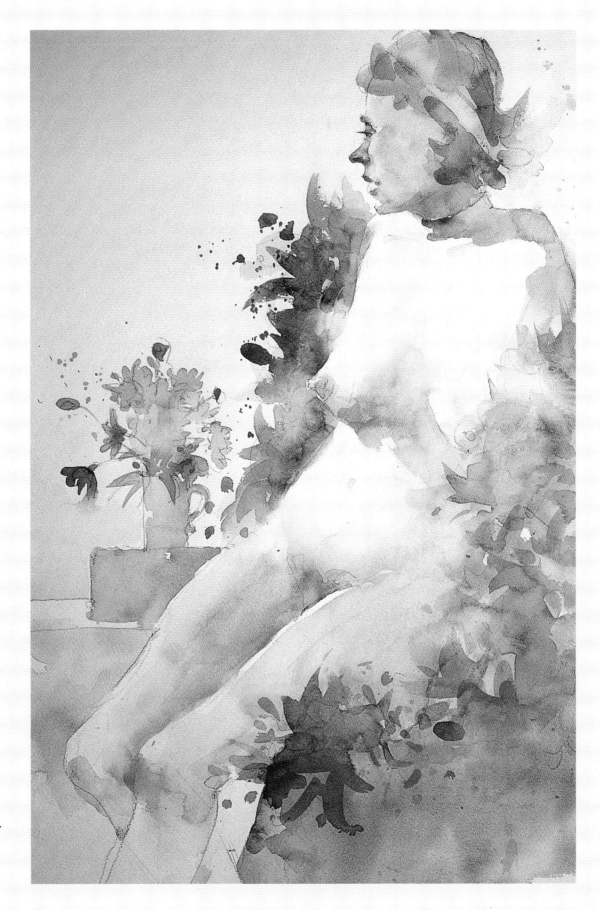

*The Feather
Boa*
22 x 15"
(56 x 38 cm)

Painting the Portrait

Do not be overly concerned with capturing an exact likeness of the model. If you concentrate on the structure of the face and the essence of the expression, the likeness will happen. Do not "copy" the features of the face. You have to realize the shape and forms of the skull under the features in the same manner that you must realize the form of the figure beneath the drapes and folds of a garment. Emphasize the caves of the eye sockets. The light on the upper eyelid as it peeks out of the eye socket is descriptive of that form and should be indicated. Squint hard at the model's face until you really understand the shadow shapes. Shadows are soft-edged on cylindrical forms: arms, legs, and so on. Cast shadows are always hard-edged. Detail in the shadow areas should be minimized. When shapes are close in value, fuse them, especially in the shadow areas where there is less distinction or contrast

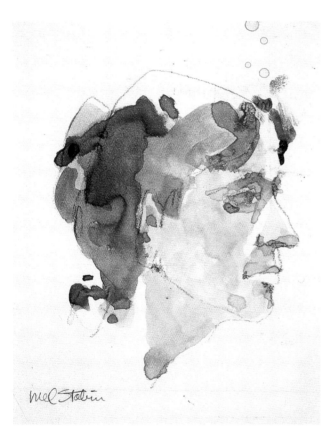

Alla Prima Portrait
7 x 5" (18 x 12 cm)

This five-minute sketch was painted on hot-press board. I let the colors splash around and have a good time. Interesting textures occur on hot-press surfaces.

Jesse, 22 x 15" (56 x 38 cm)

The decorative serape was suggested with some calligraphic marks. Had I painted the serape realistically, with all of its decorative color, it would have overpowered Jesse's face.

between shapes. Reserve the sharper edges for the light areas where there is greater contrast in values. Try to make every brush stroke count and go for the color and value that you want in the first wash. If colors aren't dark or rich enough on the initial try, you can always "glaze" a second wash, but conceptually go for it the first time. Painting "alla prima" is the most direct translation of the subject to the paper. Glazing is another method of painting whereby secondary washes are imposed over initial washes. British watercolor painters have produced masterful works using the glazing method. When applying a glaze to an area that needs a deeper value, use a color that is different than the initial wash. Be careful of glazing with earth colors—ochres, umbers, and siennas. They tend to get opaque or chalky looking quickly. Certainly by the third wash you'll be in trouble. Earth colors are semi-opaque to begin with.

Candi, 11 x 15″ (28 x 38 cm)
The colors of the silk robe were intense. I contrasted it by painting Candi's face as simply as possible.

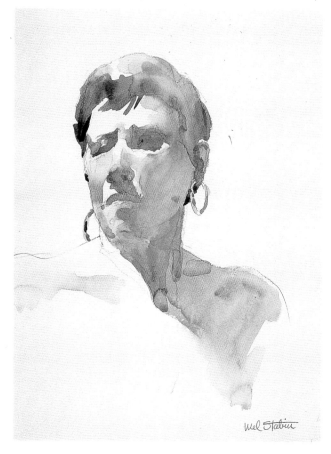

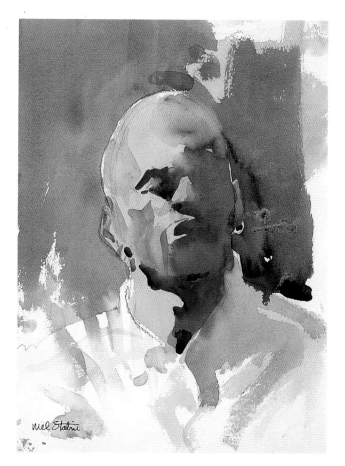

Sleeping Model
15 x 11″ (38 x 28 cm)

To avoid lifeless dark caves in the eye sockets, I imposed strong color changes. The hot light caused the model to get drowsy.

Strong Face
15 x 11″ (38 x 28 cm)

This is more of a value painting than a color idea. The sculptured look of the features were my focus.

OPPOSITE
Black and Blonde
22 x 15″ (56 x 38 cm), (Collection of Nancy Zwerling)

This painting turned out a little strange, but I like it a lot. It isn't trite. The black hat was painted wet-in-wet and went wild. Water-color is most exciting when it is set free.

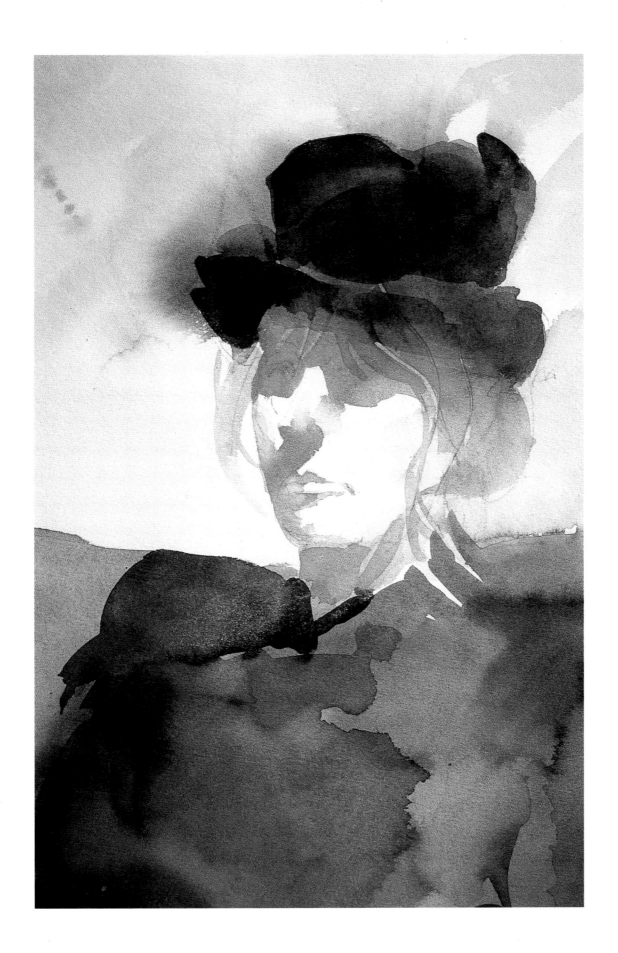

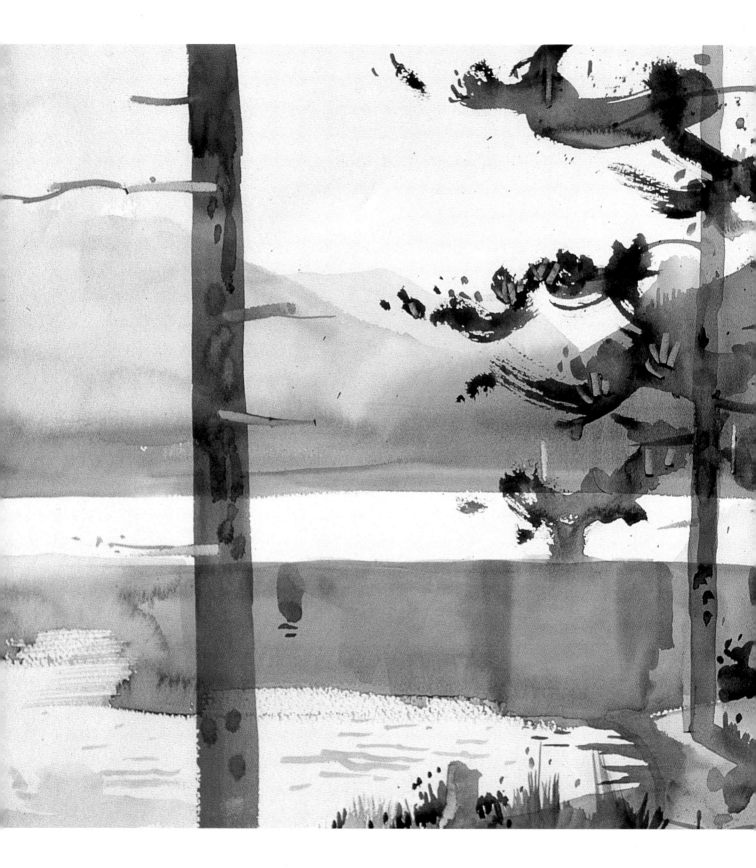

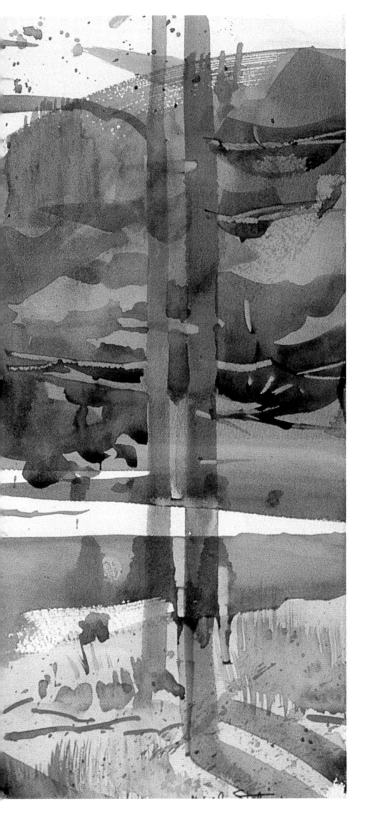

Cooper Lake
15 x 22″ (38 x 56 cm), (Collection of Jim Adair)

Painting Outdoors

Nature: The Best Teacher

Painting watercolor on location has occupied my enthusiasm for over thirty years while conducting watercolor "funworkshops" throughout the country and abroad.

The merits of "where" one paints can be debated. Painting indoors has its advantages. You are protected from weather conditions, you have the leisure of thinking and painting for as long as you want, and you have all the comforts of home. The disadvantage, I feel, is that only the sense of sight is available to you, plus your imagination and the aid of reference sketches and photos to help create a painting.

Painting on location tests the ingenuity, curiosity, and adventuresome spirit of the painter. Sun, wind, rain, rocks, surf, snow, sand can all potentially cause difficulties unless you and are prepared to deal with nature. The best thing about painting outdoors is that all of your senses are alive and active. You can taste the salt water in the air and hear the *sound* of gulls when you are painting surf. You can feel the quiet solitude when in a pine forest, the sweet smell of wildflowers in a meadow, and the incredible sight of a receding mountain range. There is also the joy of packing lunch and eating it "on the spot" as you drink in the day.

Interpreting Nature

Nature is and will always be the great teacher and source of inspiration for the artist's soul.

The location painter has to paint quicker than when painting indoors. This helps you worry less about unnecessary detail and, instead, forces you to go for the spirit or essence of the subject.

The nature can never be "captured" by "copying" it. All of the elements necessary for creating a painting exist in nature. Your objective is to recognize, select, and forge these elements into a personal expression.

It is not our job as artists to transcribe nature but rather to translate, or interpret, it.

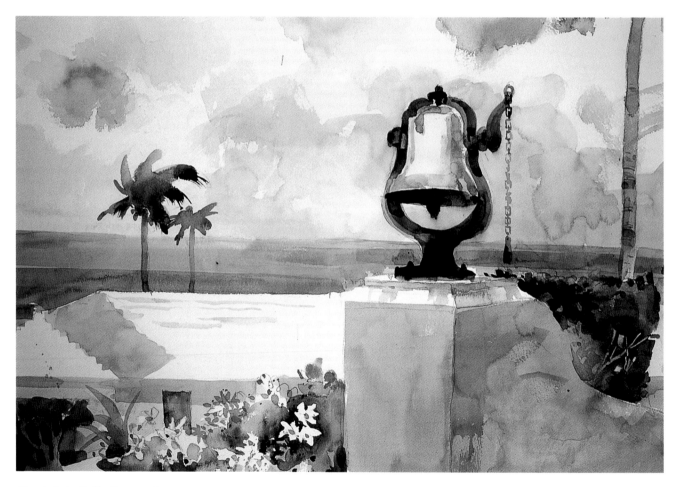

Captain's Bell, Bermuda, 15 x 22" (38 x 56 cm)

The bright brass bell seen against the clouds became the dramatic focus of this painting. The verticals of the bell, chain, and palm trees added excitement to the tranquil horizontals of the water and the white bungalow.

Sargent in the Alps, 15 x 22" (38 x 56 cm)

Color becomes more exciting when there is variety within it. Color can vary in intensity, temperature, and value. The purple mountain begins on the left as a darker blue-purple then goes to a lighter warm purple. There are a variety of warms and cools throughout the greens, as well as in the cast shadow of the hat on Sargent's face. The reference used for this painting was a very contrasty copy of a small black-and-white photo.

Spanish Wall
15 x 22" (38 x 56 cm)

Ancient stone walls abound in Andalusia, Spain. This wall was about 40 feet high and had a road running on top of it. I applied rich dark washes to the shaded wall with vigorous brush strokes. The dominant dark purple wall complements the light sunny scene beyond it. The composition was kept very simple.

Estuary
15 x 22" (38 x 56 cm)

Large, juicy washes were applied and encouraged to fuse with each other, to represent the wetness of this marsh.

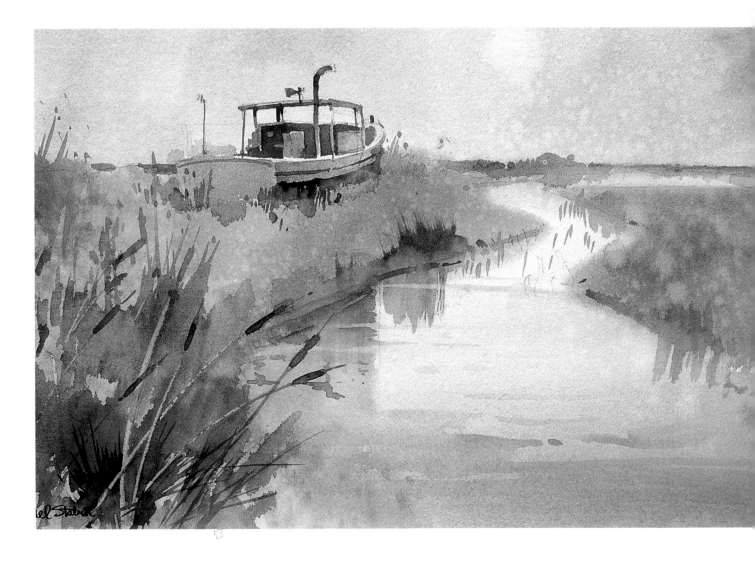

Painting People Outdoors

Use the same principles of design you would use to paint people outdoors as you would to paint people indoors, or that you would use to paint anything—even an armadillo. Regardless of subject matter, these principles prevail. There are, however, some different considerations. Natural light filters through everything outdoors, as opposed to the concentrated warm light of the flood lamp on a model in a studio. Environment is important to the painting of people outdoors. The natural environment helps to describe people's lifestyles, activities, or moods.

Capturing the essence of the moment is the objective of painting people on location. You need to work quickly and with vigor. People do not stand still very long. This scares many artists but it excites me. I seem to gravitate toward busy places. When I am painting a group of people in action, I observe their attitudes and then sketch one dominant figure. I then relate other figures to that dominant one and to the environment that they exist in. Knowledge of drawing and anatomy is essential when painting people in watercolor. Paint them briskly and simply. Again, suggest rather than include every blessed detail.

Fulton Fish Market, 9 x 12" (23 x 30 cm), (Collection of Bud and Bernice Hoyt)

The smooth surface of this paper allowed paint to "float" on it, resulting in very transparent washes. I sketched and painted quickly and tried to indicate the busyness of the fish market. The hot permanent red in the building provided a dynamic contrast to the blue-gray of the wet street and the workers. The painting was completed in forty minutes.

The Old Boys' Club
15 x 22" (38 x 56 cm)

This painting was done in a village near Santorini, Greece. Dominance of the figure in the doorway was gained by silhouetting him against a dark value. The horizontal rhythms of the roof, windows, figures, and curb constitute a directional dominance. It was a hot, sunny day that I indicated by leaving a lot of untouched white paper.

La Grande Dame
15 x 22" (38 x 56 cm)

One of my students posed for this painting on Block Island, Rhode Island. The dominant blueness of the painting communicated tranquility. This color scheme expressed the "feel" of the day—fresh air and ocean.

Farmhouse in St. Rémy

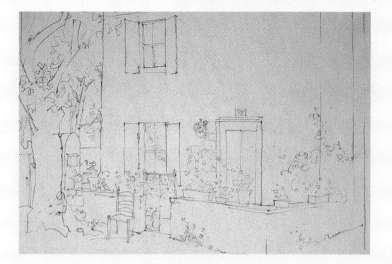

In a workshop that I conducted in Provençe, I was taken with a beautiful cast shadow streaking across the façade of this farm-house in St. Rémy creating a mood that was made for a watercolor painting. Most of the paper is occupied by the dominant shape of the house and cast shadow. The neutral mid-tone shadow served as a foil for the excitement of the flowerpots, entrance gate, windows, and tree.

Before I begin a painting, I distill my understanding of the dynamics of the subject and then emphasize it.

1 I briskly sketched the main elements, allowing my 4B pencil to meander all over the 140 lb. Arches cold-press paper. There was no attempt to report the minutia of detail, but rather to indicate the busyness of the subject.

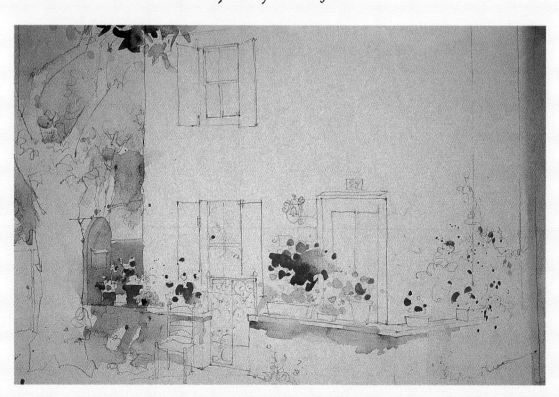

2 I wanted to "suggest" the many details that I saw without getting too fussy. I applied some loose, wet washes to indicate foliage, cast shadows of the low walls, and spattered some red and purple paint to get some excitement in the potted plants.

3 The large important cast shadow was painted next as a mid-tone value. I established a gradation of color and value in the shadow-darker and purple at the left edge of the house to a slightly neutral gray as the shadow approached the sunlight toward the right. After I was satisfied with the mid-tone areas of the painting, I proceeded to define foliage, tree trunk shadows, plants, the gate, door, and windows.

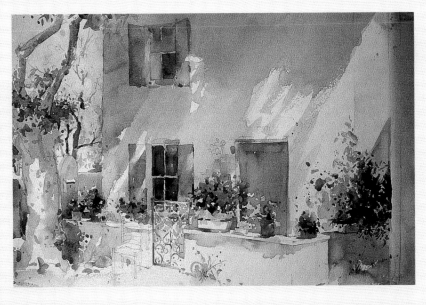

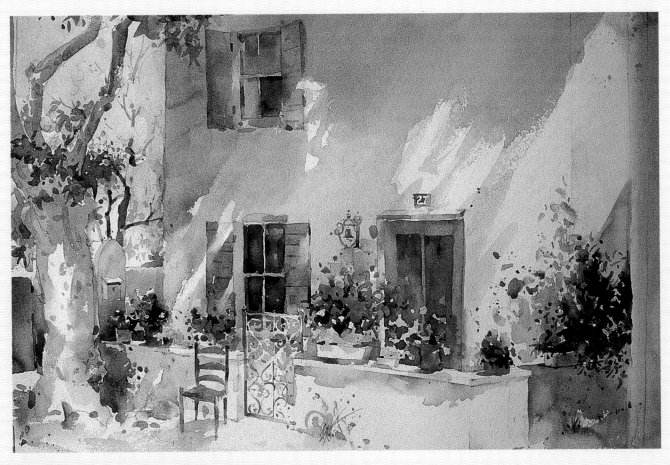

Farmhouse in St. Rémy, 15 x 22" (38 x 56 cm)

4 Most of the detail was suggested by quick brush strokes and placing dabs of hot colors next to cool colors and rich darks next to lights. The last twenty minutes of the painting was devoted to the details of the doorbell, the number above the door, the chair, and a few darks. The painting was done alla prima—laying down a wash once and leaving it alone.

The Outdoor Workshop

If you are selecting an outdoor workshop, here are some things to consider. First and foremost are the qualifications of the instructor. By that, I do not mean only the printed credentials. Some credentials are meaningful, some are meaningless. It is important to know the true teaching skills of the instructor. Is the instructor knowledgeable, engaging, encouraging? Does the instructor have a sense of humor? Are the instructor's lectures informative? Does the instructor demonstrate and critique? Do you like the instructor's work? Does the instructor relate to the students? Is the instructor a "giving" person? Does he or she inspire? Does the instructor have a good reputation?

Word of mouth is the best recommendation for choosing an instructor. Articles, books, and videos that a teacher has produced are other ways to gain some insight. Of course, choice of location, cost, and time are also considerations in the selection of a workshop.

If you have attended workshops and are fortunate to discover an instructor who meets most of the criteria we just discussed, stay with him or her. Sponge as much as you can from the instructor's teachings. Some instructors dry up quicker than others. A good instructor will continue growing as well as the students. If the instructor has no more to say and you've learned all you can, it is probably time to move on. The teacher and the students are, in a sense, both attending school. One is giving, the other getting.

I was fortunate indeed in knowing and painting with Edgar Whitney, arguably one of the most influential teachers of this century. He instilled in me the passion for painting. I've never lost that passion. In fact, it seems to grow more intense, as does my quest for knowledge.

Now that we are on location, what shall we paint? I suggest that you do not spend an inordinate amount of time looking for the perfect scene. It does not exist. Trust your feelings. When you encounter a subject that moves you, that you fall in love with,

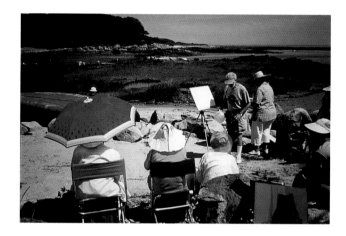

Outdoor workshop in Turbotts Creek, Cape Porpoise, Maine.

stay with it. Do not spend time looking elsewhere. First love is always sincere and exciting—prerequisites for any work of art. First love grows stronger with familiarity. It is your personal interpretation of a scene that will give meaning to your painting. Be clear about your idea for the painting and then just get started. This is the moment of truth, when you have to draw upon your knowledge of design and synthesize it with your feelings about the subject. Have an easy attitude. Hey, it's only a painting.

Think simply, work energetically, and stay focused on the essence. Paint *your* impression of the location. Isn't that why you're out there? Squint a lot. Squinting helps to simplify values and shapes. Enjoy the day. If you do, your enjoyment will be reflected in your painting. If you are "uptight," that will also be evident in your work. For sure you will experience both exhilarating and frustrating moments as you paint. It is all part of learning and growing. Accept it.

The workshop instructor should get to you as you are painting and help resolve problems that you may have. Some students need more attention than others. I think it is best for the instructor to point the way but allow students to discover things for themselves.

Class critiques, given at end of day, are an important part of the learning process. Students get to see each other's work and greatly benefit from the evaluation. This is the time to ask questions. There should exist an easy, spirited dialogue between the instructor and students at the class critique.

A few words about equipment. Travel light. The experienced workshop participant takes only what is necessary. Most locations require comfortable casual clothing. Don't overpack. You are in a workshop to paint. If there is going to be an evening that requires more elegant attire for dining, then a jacket or dressier dress may be appropriate. Other than that, a light windbreaker, sweater, jeans, sneakers, cap or hat, sunblock, sunglasses, light rain gear, insect repellent, and not much else are all you'll need.

Your painting gear should be ample but light and should fit into a strong carrying bag. If you are flying to a location, take your painting gear onboard if it is able to fit into an overhead bin. One of my students, on her way to my workshop in Mexico, checked her painting bag with the airline and it was lost for five days. She had to get by by borrowing equipment from fellow students. I *always* carry on my gear. If my stuff gets lost, I'm out of business. For specific information on equipment, refer to Chapter 1.

Wood Shed, 15 x 22″ (25 x 56 cm), (Private collection)

Soft, fused areas in contrast to sharp-edged shapes are seen throughout this painting. The strong horizontal direction of the shed is interrupted by the vertical tree trunks and the spider web structure seen in the shed opening. This conflict of shapes creates excitement.

Lydia
15 x 22″ (25 x 56 cm), (Collection of Alice Hausner)

I cannot resist painting a woman in a straw hat. I painted Lydia while she was painting in Jobson's Cove, Bermuda. Lydia, the red umbrella, and the "Spanish bayonets" were perfect together. The joys of painting outdoors come from these unexpected discoveries. You won't find them in a studio.

Varenna, Italy
15 x 22" (25 x 56 cm)

There was a lot going on here. I simplified shapes and connected as many of them as I could (squinting all the time) to avoid fragmenting the elements. Note the continuous journey of the shadow shapes and how they join the foliage.

The Artist's Journal

Keeping a visual record of places you have painted during holidays or workshops is a wonderful way to capture the moments you experienced and to hold on to memories of these trips. A small watercolor pad (no larger than 9 x 12"), pencil or pen, water container, and small watercolor kit is all that is necessary—and it all fits into a backpack. The sketches should be very casual and done quickly. Don't think of these as small paintings. The idea is to capture the immediacy of the moment and then move on to something else. Stay loose, let yourself go, and have a good time doing it. You are doing it for yourself.

These sketches should be very free, driven by your own instincts. Work quickly, have fun, and move on. Splash in some color to express the subject. Fill lots of pages. Be productive. After the sketch, snap some photos of the subject for future reference. Often these small "quickies" are gems of thought and reveal more of the personality of a place than a finished painting. They also can serve as a reference for larger paintings.

A sketch may say more than a "finished" painting.

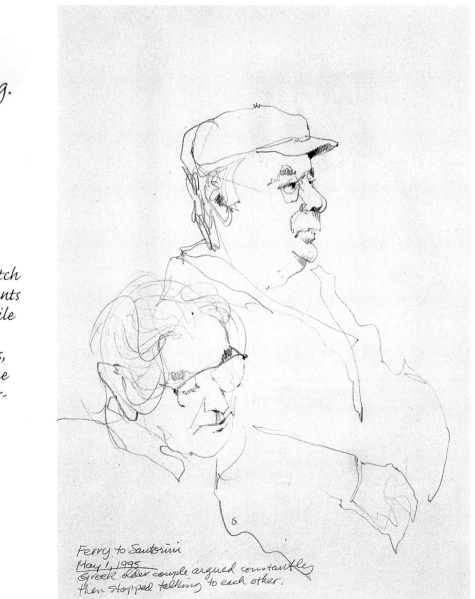

Ferry to Santorini
8 x 10" (20 x 25 cm)

I always have a small sketch pad handy to catch moments like this one, observed while riding the Santorini ferry. Sketching hones your skills, it's great fun to do, and the sketch can be used as reference for future paintings.

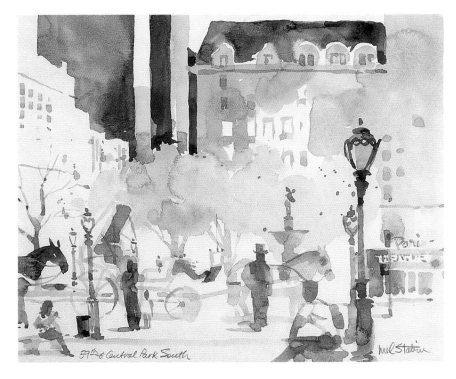

59th and Central Park South
9 x 11" (23 x 28 cm)

Painting directly, without first doing a sketch, often results in a fresh, spontaneous effort. It also helps you become more aware of shapes.

Varenna Vignette
7 x 10" (18 x 25 cm)

The strong morning light was what I was after in this small "quickie." I employed mostly sharp silhouettes of strong color to symbolize the striking light seen here.

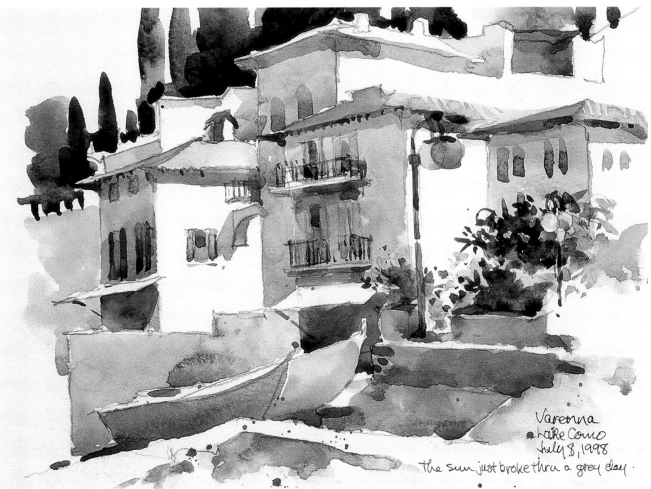

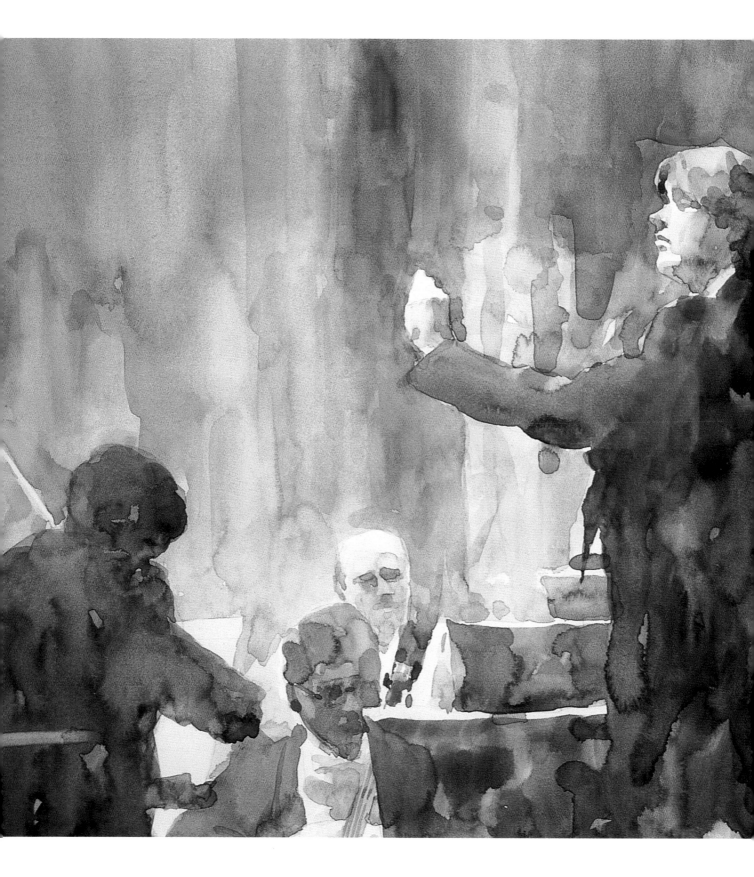

In Conclusion

If this book offered you some edification and encourages you to continue growing as an artist, then I am content. Growth comes to an abrupt halt when you become too complacent with technique or style. Philip Jamison observed that being too concerned with "style" is often a cover up for personal inadequacies.

Go beyond preconceived ideas of style. Do not be content with repeating subject matter that you've painted a thousand times before. What is the gain? The loss is to your potential growth as an artist. Growth is contingent upon production. The more you paint, the more knowledge you'll acquire, and the more knowledge you acquire, the more confident you become. The more confident you become, the better you'll paint, and the better you paint, the happier you'll be. It's simple.

Creating art is hard work, but what a wonderful job it is. One never graduates from the school of art. To become great, you have to be a great student—for the rest of your life.

The joy is in the painting itself. Just as in life, the joy is in the daily living of it, not where it gets you. Knowledge, sincerity, a scholarly attitude, and persistence will help lead to success. Success is measured by how you feel about your work—not how anybody else does. If fame and fortune come your way, all to the good, but they are by-products of your work and should not be goals. It is the work itself that really matters.

An artist's life and work are constantly evolving, changing, and growing. Confidence comes from not being afraid to fail. Do not be discouraged, for the best is yet to come.

If you try, almost anything is possible.

Finale, 11 x 14" (28 x 36 cm), (Collection of Yoko Wakabayashi)

Index